Japanese Quest for a New Vision

The Impact of Visiting Chinese Painters, 1600-1900

Japanese Quest for a New Vision
The Impact of Visiting Chinese Painters, 1600-1900

Selections from the Hutchinson Collection at the Spencer Museum of Art

Edited by Stephen Addiss

Catalogue by Stephen Addiss, Matthew Welch, and Juliann Wolfgram with Janet Carpenter, Lee Johnson, Brenda Jordan, Li-na Lin, Jen-mei Ma, and Chih-p'ing Wang

SPENCER
MUSEUM
OF ART
The University of Kansas

Cover: I Fu-chiu, Mount T'ien-t'ai (detail)

Designed by Janet Moore
Photography by Jon Blumb
Managing Editor Carol Shankel

Table of Contents

Acknowledgements

This exhibition opens up a new area of Far Eastern art to the West. Information on many of the artists is scant; connoisseurship of paintings, when there are so many copies extant, is not yet far advanced. This catalogue has had the benefit of consultation and advice from many friends and experts in the fields of Japanese and Chinese painting. The authors and the staff of the Spencer Museum of Art gratefully acknowledge the following scholars for their assistance: Paul Berry, Tsenti Chang, Pat Fister, Junghee Han, Iwasaki Tetsushi, Kawai Masatomo, Nara Hiroshi, Choon Sang Leong, Joseph Seubert, Tsuruta Takeyoshi, and Kwan S. Wong. We also thank and congratulate Mitchell Hutchinson for his own "quest for a new vision" in collecting so astutely in a little-known area of Oriental brushwork, and for his generosity to the Spencer Museum.

Preface

Oriental culture and art were part of my family life from infancy. My father edited Methodist publications in China, so I was taken to live there at the age of six months. For the next five years we lived in Nan-ching, Shanghai, and the mountains of Chiang-hsi province. When we returned to the United States I spoke only Chinese and had to learn English quickly; unfortunately, Chinese was forgotten almost as precipitously. Nevertheless over the years interest in Asian culture continued to grow; I began my serious study of Chinese painting in 1949 at the University of Hawaii under Professor Gustav Ecke, who was also a curator at the Honolulu Academy of Arts. Under the guidance of this distinguished scholar, I learned to prefer *wen-jen hua* (literati painting) to the then more popular and easily appreciated works of professional artists of the Ma-Hsia and Che schools. My first purchase in 1950 was the hanging scroll *Two Trees* in the manner of the Ming dynasty scholar-artist Wen Cheng-ming by Tseng Yu-ho (Professor Betty T.Y.H. Ecke). I moved to Chicago with my family in 1953, and the Eckes continued to give me their advice on purchases; I mailed photographs or original works to them for their examination. During this period I also bought some paintings without consultation, most of which turned out to be expensive mistakes.

At this time my exposure to Japanese art, particularly *bunjinga* (scholar painting), was peripheral. I appreciated the occasional fine work I might happen to see, but gave this form of painting no serious study until I met the scholar-artist Kwan S. Wong. He introduced me not only to the paintings of I Fu-chiu and other Chinese artists who visited Japan, but also to works by Japanese painters whom they influenced. Serious study of Nanga and its sources followed, and I began to purchase paintings by Japanese *bunjin* as well as by visiting Chinese *wen-jen* artists. The superb qualities of Japanese design, composition, and use of color which the *bunjin* brought to literati painting provided a new aesthetic experience. Because *bunjinga* was a form of Japanese art strongly influenced by the literati painting of China, I found it exciting to search for and collect paintings and illustrated books that documented the links between the arts of the two countries.

In 1974 I had the opportunity to meet many scholars and experts at Professor Calvin French's exhibition and symposium on *The Poet-Painters: Buson and His Followers* at Ann Arbor. It was intriguing that although no serious study was contemplated, there was widespread interest in the subject of visiting Chinese artists among those attending. Professor Stephen Addiss (then a doctoral candidate) was particularly interested in the two I Fu-chiu landscapes I carried with me to Ann Arbor. His enthusiasm encouraged me to continue studying and collecting in this area.

By the time of Professor Richard Edwards' 1977 exhibition and symposium on Wen Cheng-ming in Ann Arbor, I had acquired several paintings by such artists as Taiga, Kaiseki, and Aigai inscribed as following or inspired by I Fu-chiu. I had also continued purchasing works by other Chinese artists who visited Japan. Interest among the scholars in the few paintings I brought along to the symposium was encouraging, especially since most of the experts present were not involved in the study of Japanese painting of any kind.

Since 1977 the collection has continued to grow with the advice and assistance of scholars whose help can not be adequately acknowledged. My deep gratitude goes to Professors Stephen Addiss, James Cahill, Betty Iverson Monroe and Harrie Vanderstappen. Also very important were the dealers who searched for important artworks on my behalf. In this regard I wish to thank Dr. Frederick Baekeland, Ms. Shirley Day and Mr. Andreas Leisinger.

My particular appreciation goes to Mr. Kwan S. Wong, whose help began while he was still a student and without whom this collection would not exist. Mr. Wong is unusually if not uniquely trained, with graduate degrees in Chinese and Japanese culture and art history from Chinese, Japanese, and American universities. He is also an accomplished artist in calligraphy, landscapes, and other *wen-jen* subjects.

My special thanks also go to Professor Addiss, who, in addition to the advice and help he has given over the years, is the organizer of this exhibition and co-author and editor of the catalogue. Dr. Patricia Fister, Curator of Oriental Art at the Spencer Museum, has also assisted this exhibition a great deal in many ways. The contribution of Japanese scholars is more adequately acknowledged elsewhere, but I must express my personal thanks to Iwasaki Tetsushi, Kawai Masatomo, and Tsuruta Takeyoshi.

To the graduate students who have worked so hard and contributed so much, my envious thanks. Would that I could have joined such a research project when I was in school!

Mitchell Hutchinson
Honolulu, January 1986

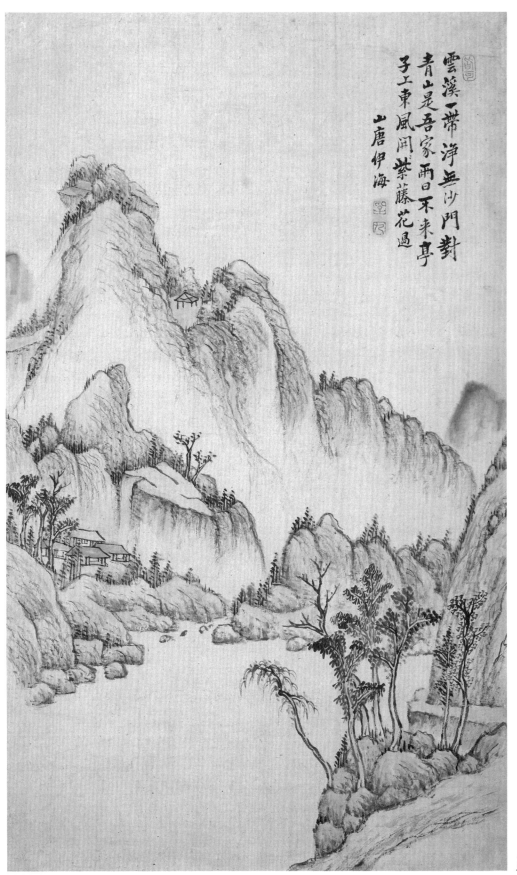

雲溪一帶淨無沙門對
青山是吾家兩日不來亭
子上東風開紫藤花過

山唐伊海

3 I Fu-chiu,
*Return to My
Mountain Home*

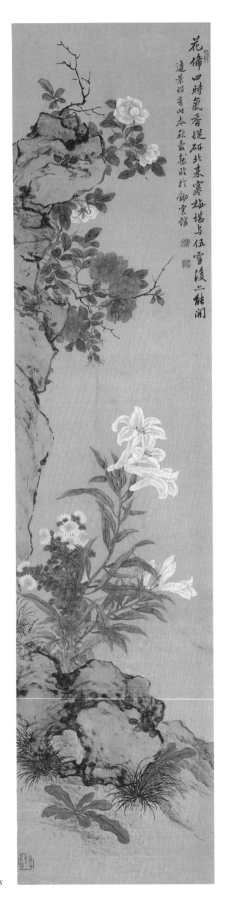

花備四時氣香送研北來寒梅塢與伍雪後一種開
邊景昭看此本秋素蔥玳於鋤雲館

21　Chang Hsin, *Lilies and Roses*

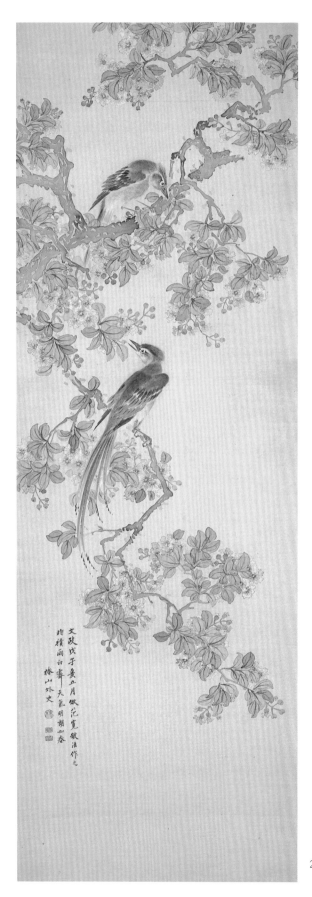

23 Chinzan, *Birds Amid Cherry Blossoms*

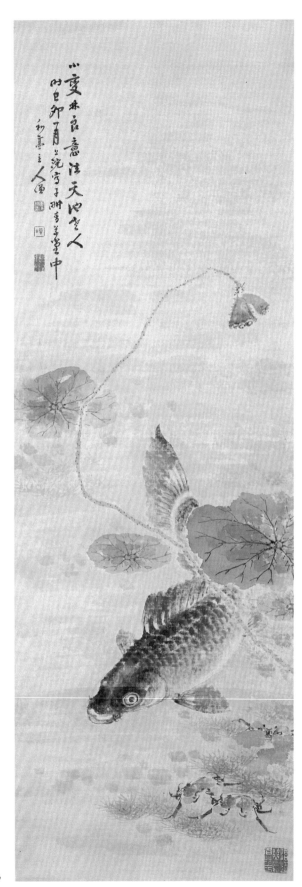

26 Katei, *Shimmering Carp*

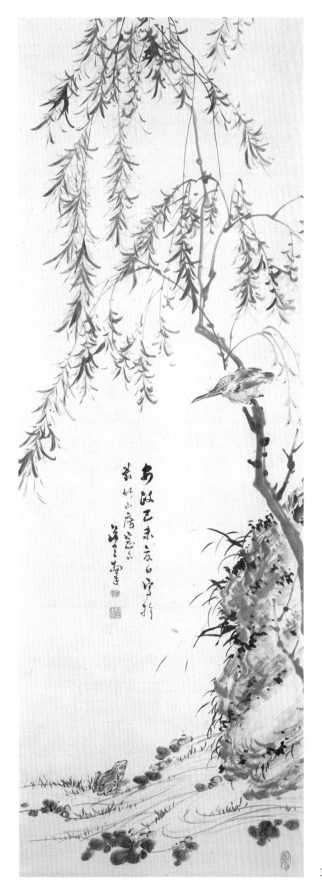

33 Itsuun, *Kingfisher and Frog*

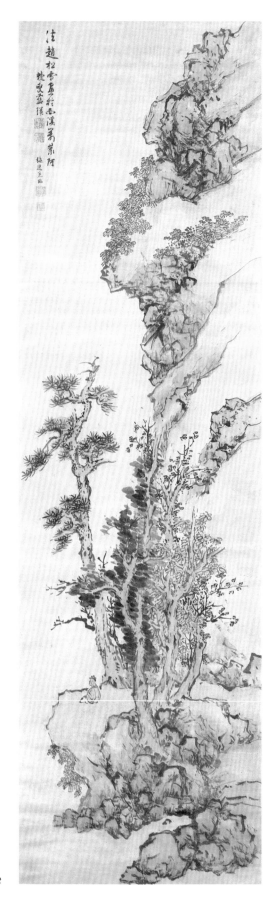

37 Baiitsu, *Autumn Contentment*

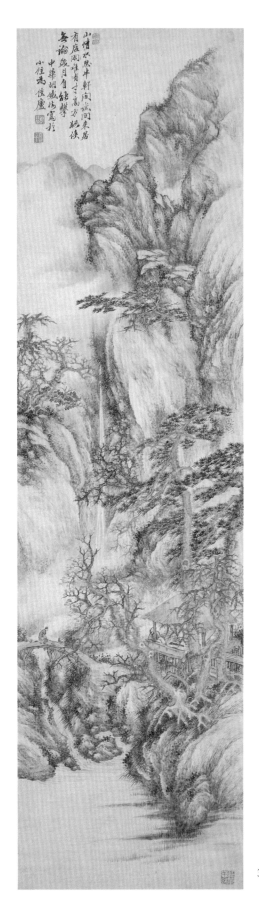

38 Hu Tieh-mei, *Mountain Hermitage Landscape*

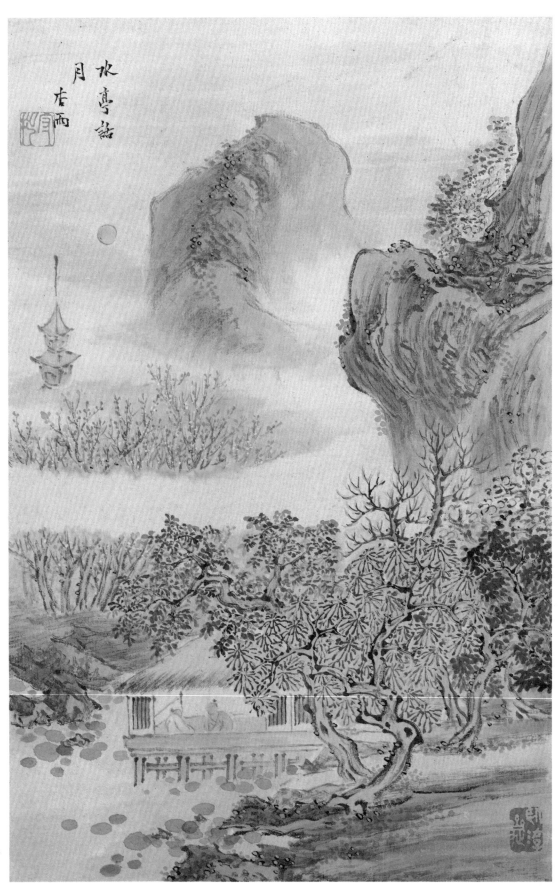

水亭月話
店雨

50 **Kyōu**, *Conversation
Under the Moon in the
Waterside Pavilion*

Introduction

One of the most fascinating areas of art history is the study of the influence of one culture upon another. This is particularly the case with Japan, which has borrowed so much from outside its shores and yet has created such a unique and remarkable way of life. Until the past one hundred years, its primary source was China, which three times invigorated Japanese culture with large-scale exportations of religious, philosophical, and artistic influence.

The first wave of Chinese influence in Japan brought with it Buddhism, a system of writing, political and educational advances, and a multitude of art forms which were eagerly adopted by the court and the citizenry. The sixth and seventh centuries saw the wholesale transformation of Japan into a country modeled strongly upon Chinese customs and principles. During the following centuries the Japanese gradually assimilated these influences into a native culture that reached its apex in the grandeur and lofty artistic sensibilities of the Heian court, as represented in the novel *Genji monogatari.*

The thirteenth and fourteenth centuries saw the second wave of Chinese influence, stimulated by the Japanese warriors' acceptance of Zen Buddhism and the disciplined and restrained culture that came with it. Chinese poetic and ink painting traditions were developed in Japan by Zen monks who came to dominate education as well as culture during the Muromachi period (1333–1568). Again these influences were slowly assimilated until a Japanese Zen style emerged that could be clearly distinguished from that of China.

The third wave of Chinese influence in Japan took place during the Edo period (1600–1868). As it did not affect the totality of culture as completely as had the earlier cultural borrowings, it has not been as thoroughly studied, but it nonetheless caused major repercussions in Japanese art. Fundamental to this wave of influence was the Tokugawa government's decision to rely on neo-Confucianism rather than Buddhism or Shintō as an official way of thought. Despite the limitations imposed by the Shogunate on foreigners in Japan (Chinese were limited to the port city of Nagasaki), Chinese philosophy, ethics, history, and eventually literati arts became studied and practiced in Japan.

The first Japanese to embrace neo-Confucianism in the Edo period were primarily philosophers and statesmen, eager to provide the new government with theories and standards under which to operate. As time went by, however, the number of Confucian-trained scholars increased and the opportunities for government service became more limited; at this time many scholars turned to the arts. Chinese-style poetry, always popular in Japan, was one of the first arts to be seriously practiced; calligraphy in Chinese characters was not far behind. Painting was late to be accepted, for reasons that have not yet been thoroughly explored. By the seventeenth century, China had already developed a rich heritage of scholar painting, with special techniques, styles, and theoretical background all fully established. Yet it was not until the beginning of the eighteenth century that Japanese artists took up the literati tradition, which was given the name Nanga (southern painting).

One theory for the Japanese delay in accepting literati painting is that there was a lack of models available to native artists. It has been generally accepted that the Japanese learned from imported Chinese woodblock books and from the few paintings that were brought over by merchants from the mainland. The influence of visiting Chinese artists in Japan has not been fully acknowledged, but here too the visitors were mostly painters who came during the eighteenth and nineteenth centuries.

The case of Ch'en Yuan-yun (1587–1671), however, proves the situation is more complex and interesting than has hitherto been supposed. This artist arrived in Japan in 1638 and stayed in his adopted country until his death thirty-three years later. Although Ch'en was an accomplished painter in the literati tradition, he had much more success in Japan as a scholar, potter, and teacher of *kung-fu.* This suggests that even with an exemplar of the tradition at hand, the Japanese were not yet ready to accept the literati style. When I Fu-chiu (1698–after 1747) arrived almost one hundred years later, he proved to have a significant and lasting effect upon Japanese art, although he was no more skillful or gifted a painter than Ch'en.

It is clear that when Japanese intellectuals were first absorbing Chinese philosophy and poetry, they were not ready for the subtleties of literati painting. These same subtleties were eagerly accepted when the artistic climate was propitious, as can be seen in the works of the Hutchinson collection. Ch'en Yuan-yun was "before his time" in terms of influencing Japanese painting, and remains an historical reminder that artistic influences are only accepted when the recipients are ready to absorb the impact of a new vision. SA

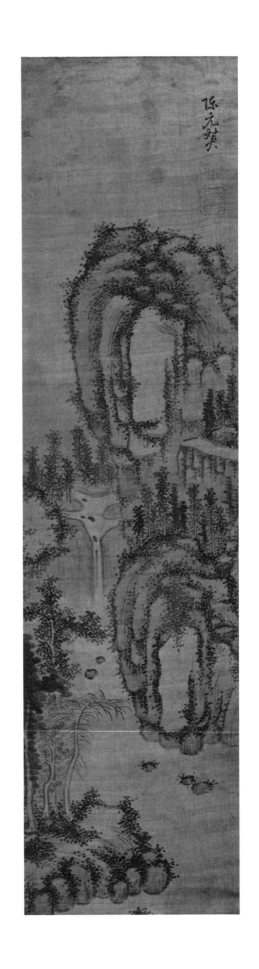

1. Ch'en Yuan-yun (J: Chin Genpin, 1587–1671)

Mountains and Waterfall
Ink on silk, 118.7 × 31.6 cm.
Signature: Ch'en Yuan-yun
Seals: Chi-pai shan-jen, Ch'en Yuan-yun

This landscape together with another landscape in the Hashimoto collection in Japan comprise the only known paintings by the artist Ch'en Yuan-yun. He is important as the first Chinese literati artist who went to Japan early in the Edo period, even though few of his works survive. Perhaps more is known about Ch'en's activities in Japanese intellectual circles and his roles as potter and teacher of *kung-fu*.

Ch'en Yuan-yun was born in the town of Hulin in Che-chiang province. He descended from a family of literati, the most famous of whom was a Northern Sung scholar, Ch'en Chien-cha. Ch'en Yuan-yun learned poetry and calligraphy from his family, particularly studying the works of the Yuan master Chao Meng-fu. Having failed his civil service examinations at the age of seventeen, Ch'en trained for over a year in the arts of *kung-fu* and pottery at the Shao-lin temple. In 1638 Ch'en journeyed to Nagasaki, although the reason for this trip is unknown. Illness prevented his planned return to China, and his popularity with the Japanese people led him to remain in Japan for the rest of his life, eventually becoming a Japanese citizen.

Ch'en's acclimation to a Japanese lifestyle was probably aided by his knowledge of the Japanese language. In 1622, this led him to become the translator for the Chinese ambassador to Japan. Popular as a writer, Ch'en collaborated with his friend the Nichiren sect monk Gensei (1623–1668) on a book of poems known as *Motomoto showashū.* Ch'en may have been the first person to bring *kung-fu* to Japan. He taught this art for a number of years at a temple in Edo. Beginning in 1638, Ch'en served Tokugawa Yoshinau, the governor of Owari, until the artist's death in 1671.

Mountains and Waterfall shows the artist's use of overlapping landscape elements to lead the viewer's eye diagonally upward to the left, creating an illusion of depth. The composition is balanced on the left side by the introduction of rock forms and trees which are larger and more individualized through the use of a greater variety of brush strokes. The mountain shapes are formed by a dry brush outline with repeating square and rectangular shapes which are given breadth by the application of wash. Clusters of dots in varying tones of black and grey cover the interstices of the rock forms and indicate foliage patterns on distant trees.

These dots soften the angular forms of the cliffs, giving the painting a sense of lush summer verdure. The waterfall flows down to a river with small stone islands located in space cells between the trees and rocks.

Ch'en's skill as an artist is apparent in this landscape, but the lack of response to his style in Japan must have discouraged him from developing his career as a painter in his new homeland. This scroll was once owned by the Meiji period master Tomioka Tessai (1836–1924), indicating that the works of Ch'en Yuan-yun were more appreciated in the latter days of Nanga than during his own lifetime.

LJ

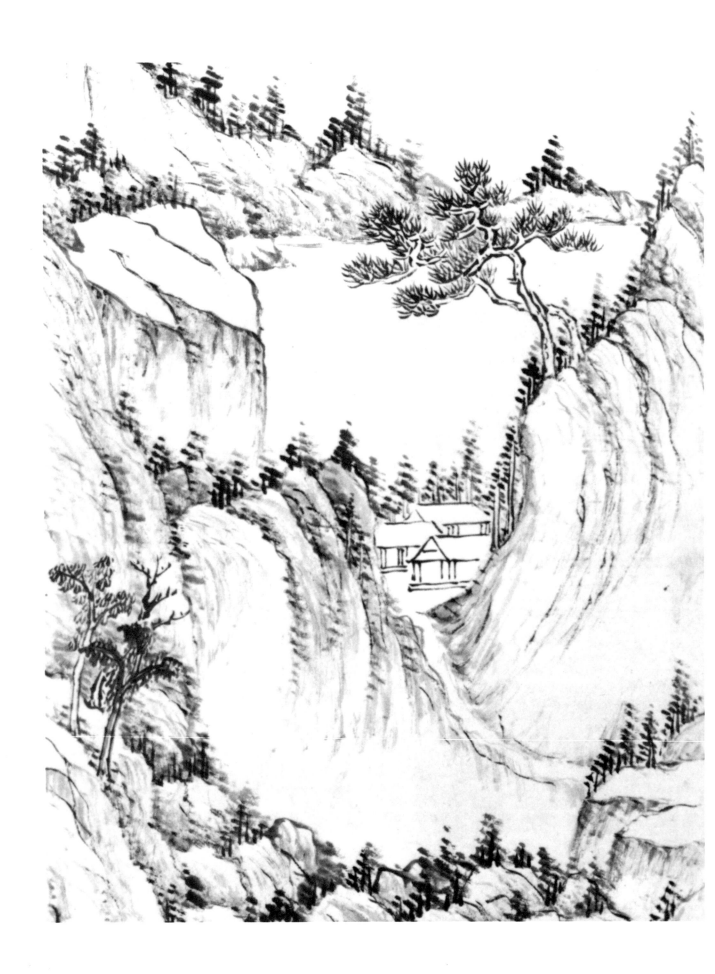

Part One: The Influence of I Fu-chiu

By the early eighteenth century, Japan had enjoyed one hundred years of peace and relative prosperity, during which time the patronage for art had gradually expanded to include merchants and scholars as well as temple, court, and government officials. The traditional schools of painting maintained their positions, but with a concomitant decrease in creativity. Confucian scholars in particular began to seek new forms of artistic expression; as might be expected, they turned to China where a strong literati painting tradition had long been dominant.

Students of Japanese scholar painting have focused upon two primary sources of influence: Chinese woodblock books and the few imported literati paintings that reached Japan during the middle Edo period. Visiting Chinese artists, however, were an equally significant influence upon Japanese Nanga. In terms of landscape painting, the most important of these Chinese visitors was the merchant I Fu-chiu (1698–after 1747), who made a series of journeys to Nagasaki between 1720 and 1747. Although he was not a major artist, I Fu-chiu embodied in his landscapes the "bland" and restrained poetic spirit of the Chinese Yuan dynasty masters, and thus represented a legitimate literati source for Japanese scholar-artists. In complete contrast to the indifference shown Ch'en Yuan-yun's works a century earlier, Japanese intellectuals now treasured the paintings of I Fu-chiu, copied them, and published books of his landscape compositions.

Not only did young painters of the middle eighteenth century admire and copy I Fu-chiu's works, but Nanga masters of succeeding generations also modeled paintings after the style of the Chinese visitor. One may trace almost the entire history of Nanga through the tradition of I Fu-chiu as it was reinterpreted generation after generation. Conservative artists such as Kan Tenju (1727–1795) and Noro Kaiseki (1747–1828) were often content to copy the forms of the Chinese visitor without a great deal of modification, although their own personal touch with the brush is always apparent. More innovative painters like Ike Taiga (1723–1776) transformed the restrained idiom of I Fu-chiu into lively and eccentric landscapes that demonstrate the creative freedom of much early Nanga.

In succeeding generations of artists, the influence of I Fu-chiu was modified by both the personalities of the painters and the tastes of the times. Scholar-artists such as Inoue Kinga (1732–1784), Kameda Bōsai (1752–1826), and Hosokawa Rinkoku (1778–1843) maintained the simplicity and refinement of I Fu-chiu, although they did not always directly credit the Chinese visitor's inspiration in their inscriptions. More professional artists such as Takaku Aigai (1796–1843) filled their compositions with more dramatic brush strokes and a generous use of wash, giving their landscapes a rich and lush sense of volume.

Even in the Meiji period (1868–1912), when Japan turned to the West rather than to China for inspiration, the influence of I Fu-chiu was not lost. Yamanaka Shinten'ō (1822–1885) brushed his own bold and blunt version of the Chinese visitor's style, imbuing his landscape with the drama of the new age. Thus I Fu-chiu's influence lingered through the history of Japanese Nanga, offering artists a model of Chinese literati style which could be followed or transformed at will, and yet maintaining the atmosphere of continental scholarship and refinement. The Mitchell Hutchinson collection is unique in containing works that demonstrate the I Fu-chiu tradition fully and comprehensively, adding a new chapter to the history of Edo period painting.

SA

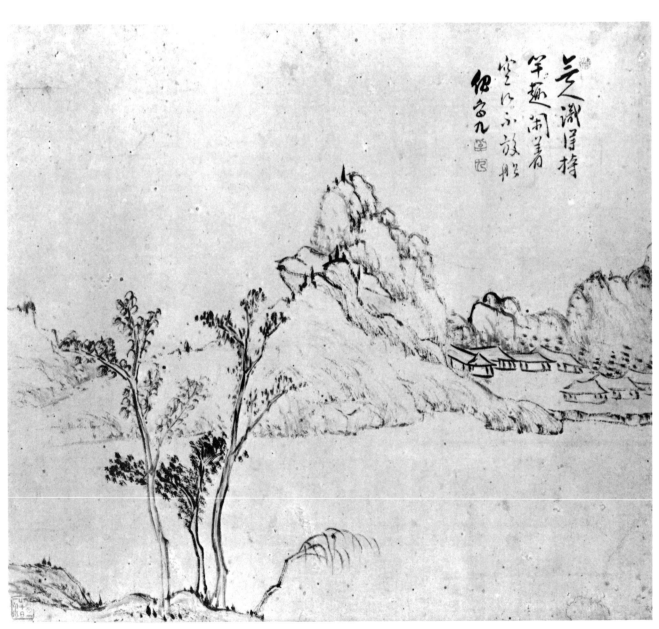

2. I Fu-chiu (J: I Fukyū, 1698–after 1747)

Quiet Hamlet
Ink and light colors on paper, 30.4 × 34.2 cm.
Signature: I Fu-chiu
Seals: Hai, Fu/chiu, Wu jih yi shan shih jih yi shui
(Five days to paint a mountain, ten days to
paint water)
Published: *Kohinten: Bunjinga o chūshin toshite* (Ex-
hibition of Small Paintings Centering Around
Literati Paintings) Tokyo: Tekisendō, 1977.

At a time when many connoisseurs were losing interest in traditional schools of painting, eighteenth-century Japanese artists pursued new sources of inspiration for their creative output. Prominent among these sources were works by the Chinese painters Shen Ch'uan (cat. 15) and I Fu-chiu. While Shen piqued an interest in the detailed and colorful academic style, I Fu-chiu nurtured the growing enthusiasm for *wen-jen hua,* or literati painting.

A native of Wu-hsien, present-day Su-chou, in Chiang-su province, I Fu-chiu grew up in a major cultural center whose art strongly reflected the literati tradition based on the Wu school of the Ming dynasty and the Four Wangs of the Ch'ing dynasty.[1] Accordingly, it is not unexpected that I Fu-chiu, or I Hai, as he was also known, would create works within a conservative style. The startling fact is that I Fu-chiu was first and foremost a merchant, succeeding his father as a ship owner who conducted an export business with Japanese dealers in Nagasaki. Although I Fu-chiu is not listed in any premodern Chinese source, Japanese documents record his first visit to Japan in 1720; subsequent sojourns were relatively frequent, ending in 1747.[2] Even his names indicate the transoceanic nature of his profession; "hai" means "sea" and "fu-chiu" stems from characters translated as "dove on a mast."[3]

I Fu-chiu painted in the manner of the Yuan dynasty masters Ni Tsan (1301–1374) and Huang Kung-wang (1269–1354), producing landscapes in a variety of formats; his *Rigō sansui* made the hanging scroll triptych with a continuous scene quite popular among Japanese painters.[4] In addition to landscapes, I Fu-chiu brushed calligraphy scrolls which were also favored among art collectors.

Quiet Hamlet is composed much like early Ch'ing versions of Ni Tsan's landscapes. A foreground land spit supports a group of four trees which overlaps the mountains in the distance. The expanse of water flowing between the two land areas is devoid of human activity; the cluster of buildings nestled in the distant cove merely hints at human presence. The extremely dry brushwork is very careful and not at all dramatic. Short strokes and subtle dots represent foliage. Longer, threadlike strokes lend mass to the rock forms. Color is added to balance the composition; a red-orange hue on the right tree relates to the similarly tinged hamlet

structures. In turn, the warm pigment is complemented by a light blue tint on the central tree. The overall effect is nearly bromidic, just the quality desired by literati painters.

I Fu-chiu's poetic inscription augments his qualifications as a literatus. Painting, poetry, and calligraphy were considered inseparable arts. The mastery and skillful combination of all three were important goals among literati: I Fu-chiu thus merited the acclaim bestowed upon him by Nanga painters.

> No one else knows the joy of fishing
> And so, let the river remain empty, free of boats

Although there is no concrete evidence that I Fu-chiu directly interacted with Japanese literati artists, he exacted a great influence on painters like Taiga (cat. 7, 18) and Noro Kaiseki (cat. 8).[5] Later Nanga artists collected his works; *Quiet Hamlet* was once owned by Kameda Bōsai (cat. 10, 11) and Tani Bun-chō (1763–1840). They both inscribed the box in which this painting is stored. Kuwayama Gyokushū (1737–1812) and Tanomura Chikuden (1777–1835) both praised I Fu-chiu as one of the finest and most favored Ch'ing dynasty visitors to Japan.[6] As a result of the admiration generated by I Fu-chiu's truly amateur paintings, the Chinese merchant secured the honorable status as one of the "Four Great Masters from Abroad."

JW

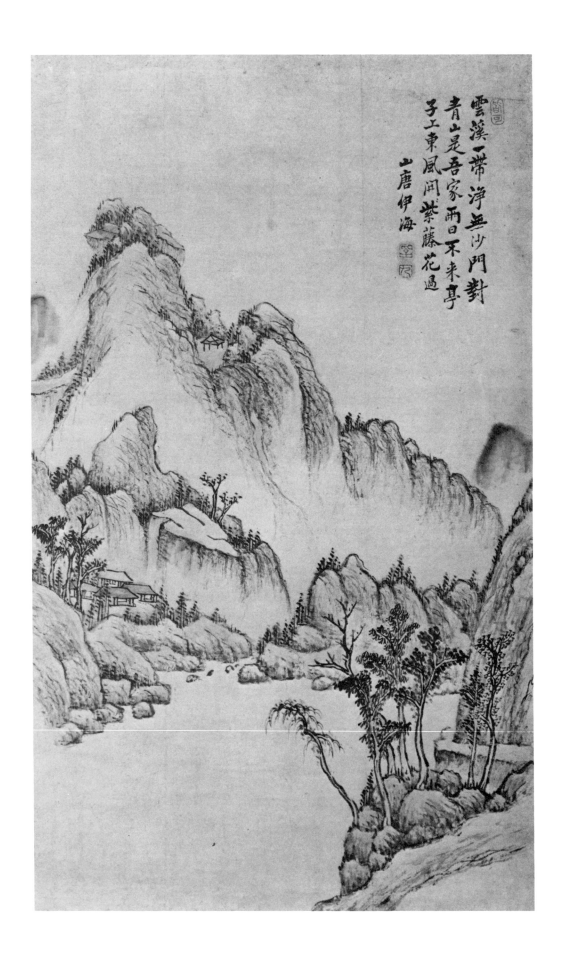

雲溪一帶淨無沙門對
青山是吾家兩日不來亭
子工東風開紫藤花過
山唐伊海

3. I Fu-chiu (J: I Fukyū, 1698–after 1747)

Return to My Mountain Home
Ink and light colors on paper, 74.3 × 44.8 cm.
Signature: I Hai from Shan-t'ang
Seals: Chieh k'o, Fu/chiu
Published: Stephen Addiss, *Nanga Paintings,* plate 1

Japanese Nanga artists were continually searching for models from which they could learn the brushwork and compositional techniques used by famous literati painters in China. I Fu-chiu provided much-desired examples of Yuan dynasty painting traditions, though he lived four hundred years later. In *Return to My Mountain Home,* I Fu-chiu formed rounded rocks and river banks by carefully layering soft, dry brush strokes that gradually crescendo in a distant mountain range. In the foreground, a mound of broken rocks supports a group of trees which nearly obscures a mountain path. On the river bank beyond the silently flowing water, several huts cluster beneath a steeply sloping plateau. High above the tranquil valley, an empty hut is nestled in a small mountain pocket.[7] This additive process of building landscape forms recalls the compositional methods employed by the Yuan master Huang Kung-wang (1269–1354) in his well-known hand scroll *Dwelling in the Fu-ch'un Mountains.*

I Fu-chiu's brushwork also falls into the brush mode tradition associated with Huang. Dry, raveled hemp-fiber strokes define the crumbly surfaces of the land forms. Wet strokes are applied in short, vertical dashes for the distant trees, which are then accented by dots representing their foliage. However, unlike Huang's horizontal dots, these accents are diagonal in orientation, beginning on the left and proceeding downward to the right. The brush movement is unusual for it resists the natural calligraphic tendency to rise rather than fall to the right. This slanting dot is a technique characteristic of I Fu-chiu which was later imitated by Japanese painters. Another aspect indicating I Fu-chiu's personal expression is his use of pastel washes. Light orange and blue shades complete the modeling of landscape forms and display I Fu-chiu's knowledge of Wu school painting methods.

The soft lyricism and serene beauty of *Return to My Mountain Home* is also reflected in I Fu-chiu's inscription.

> Clouds and streams stretch pure and free of sand,
> A gate faces the blue mountains—this is my home.
> I enter the pavilion having been gone for two days,
> The east wind has already opened the purple wisteria blossoms.

The Chinese visitor's skill in poetry was quickly recognized by the Japanese, and according to Koga Jūjirō's *Nagasaki gashi iden* (The History of Painting in Nagasaki and Related Biographies), several of I Fu-chiu's poems were published.[8] In fact, I Fu-chiu's only documented contact with Japanese literati comes from a poetry collection; the *Ōmeikan shishū* notes his association with Hosoi Heishū (1728–1801), a Confucian teacher of the Owari domain. Unfortunately, it does not explain the circumstances or reasons for the relationship.[9]

Both the paintings and poetry of I Fu-chiu were copied and published in books such as the *I Fukyū Ike Taiga sansui gafu* (Album of Landscapes by I Fu-chiu and Ike Taiga, cat. 6) and the three-volume *Sō Shiseki gafu* (A Book of Paintings by Sō Shiseki) of 1765. Many painters, including forgers, would ultimately base their works on the compositions in these woodblock printed manuals. Consequently, paintings by I Fu-chiu such as *Return to My Mountain Home* were highly prized as primary continental sources for the literati painting tradition.

JW

隔溪山閣暝朦朧
坐久鐘聲度水
東遙指石橋神
樹抄一僧歸霞
是中有王氏春三月
盧壶大和尚
伊奇

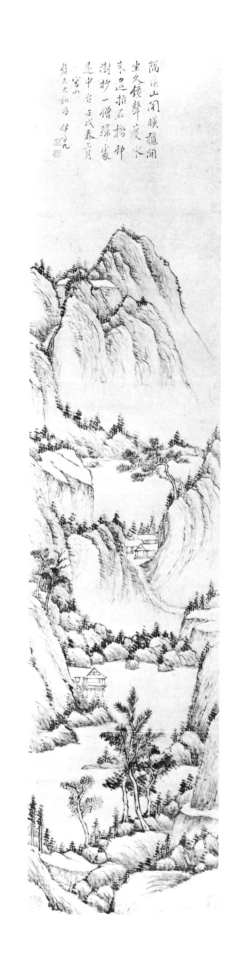

4. I Fu-chiu (J: I Fukyū, 1698–after 1747)

Mount T'ien-t'ai, 1742
Ink on paper, 136 × 31 cm.
Signature: Painted and presented to the chief priest
 Bangyoku in the third month of 1742 by I Fu-
 chiu
Seals: Chieh k'o, Fu-chiu, Jen sheng hou yu (Later
 descendant of the sage official), Jen wai chih
 shun
Published: James Cahill, *Sakaki Hyakusen and Early*
 Nanga Painting, fig. 62.

Dated works by the Chinese merchant I Fu-chiu are extraordinarily few. Equally exceptional are paintings with concomitant letters written by major Nanga artists. Both distinctions are accorded this 1742 landscape *Mount T'ien-t'ai.* A total of ten letters accompany I Fu-chiu's work, four of which are mounted in pairs and flank the tall, narrow landscape. Their content reveals not only the reason the painting was made, but also a history of its ownership immediately thereafter.

I Fu-chiu's inscription indicates that he painted *Mount T'ien-t'ai* for the chief priest Bangyoku, also known as Kaiseki Shūnan (active first half of the eighteenth century). During one of his trips to the Kagoshima area south of Nagasaki, Bangyoku met and spoke with I Fu-chiu about his lifelong desire to pray at the Chinese temple on Mount T'ien-t'ai in Chechiang.[10] Coincidentally, I Fu-chiu had received a painting of Mount T'ien-t'ai in order that he could himself make a vicarious pilgrimage to the holy site. He copied this work for the priest and added a poem, offering the same vicarious experience to Bangyoku.[11]

> Far away in a valley amidst the mountains, a pavil-
> ion reflects the tinted leaves of autumn.
> Sit for awhile, and you can hear the sound of a bell
> passing over the river valley,
> And in the far, far distance, you can see the tips of
> the trees which cover Shih Ch'iao-ts'un moun-
> tain.
> A single priest, on his way back, is now on the mid-
> dle plateau.[12]

The landscape is composed of I Fu-chiu's characteristic motifs: small boulders piled to form rounded river banks, steeply sloping mountain plateaus, huts nestled between mountain walls, and a foreground grouping of various trees. The elements are densely arranged like the compositions of Huang Kung-wang (1269–1354), but in this case the arrangement is vertical within the tall, narrow format. Also in the manner of Huang, dry hemp-fiber strokes, gradually layered, mold the land forms and create their surface textures. Distant trees are leafed in I Fu-chiu's idiosyncratic accents of diagonal dots. Light touches of wash add a sense of naturalism to the quiet scene making the imaginary pilgrimage all the more immediate.

After Bangyoku's death, *Mount T'ien-t'ai* fell into the hands of his close friend and fellow priest, Genmyō Goshin (1713–1785). His letter of authenticity is mounted to the left of the landscape scroll.

> The landscape painting by I Fu-chiu was painted
> for the chief priest Bangyoku who had gone to Na-
> gasaki. Later, it came into my possession and I have
> treasured it with great care. However, I have had to
> relinquish it to another person. The painting is gen-
> uine and a splendid work unmarred by damage, and
> so it has brought me great pleasure.
> Summer, the fifth month of
> 1779
> Jō Genmyō Goshin[13]

An unsigned letter, mounted to the lower right, attests to the fact that Goshin no longer owned the painting in 1779.

> Thank you for showing me the painting by I Hsin-
> ye. I showed it to the priest and he said that it was
> beyond a doubt the painting he owned a long time
> ago. It is an especially outstanding work highly
> praised among connoisseurs. Therefore, I asked him
> to write a letter of authenticity and am presenting
> that to you. Please treasure this painting in your
> possession.
> Most respectfully yours,
> Summer, the twenty-second
> day of the fifth month.[14]

According to the painting's box inscription, this letter was written by Kaiyū Hōin (dates unknown) who was most likely a monk in the same temple as Goshin.

Both Bangyoku and Goshin were Obaku Zen priests and friends of the major eighteenth-century Nanga artist, Ike Taiga (cat. 7, 18).[15] Taiga saw I Fu-chiu's *Mount T'ien-t'ai* and expressed his great desire to own it. His rapidly inked notes, mounted next to Goshin's letter, also contain the only comment on I Fu-chiu's brushwork.

> This is an autumn landscape painted by I Fu-chiu
> for the chief priest Bangyoku. Painted with the tip
> of a long, fine brush placed horizontally, it is a gen-
> uine work. Please take good care of it.
> The second day of the tenth
> month.

伊孚九山水一幀余法弟

鑑堂若年遊長崎永請而

所寫地後佛鄉率余於

藏多美南名公故讓芝人

為真蹟無燈趣堂芝飯題

君也故加賞鑒云

譯老以悟卯書

安永己亥夏五月

This landscape was in the possession of Ichiuan. Fortunately, it is still in his hands, having never passed from one owner to another. If there should ever be a time when the present owner wishes to part with it, by all means let me know.

Shūhei[16]

Taiga's ardent wish to own authentic works by the Chinese visitor was shared by many Nanga painters during the Edo period. Kan Tenju (cat. 5) and Noro Kaiseki (cat. 8), among others, would often voice similar praise and desire for I Fu-chiu's works.

Aoki Shukuya, Taiga's pupil and successor to the Taigadō (cat. 45), eventually managed to acquire *Mount T'ien-t'ai,* treasuring the painting because he remembered that his master had wanted it. However, later circumstances induced Shukuya to relinquish his prized possession. His letter, mounted on top at the right, is ostensibly a transfer of ownership addressed to Katō Yohachi (dates unknown).

> As promised, I am sending you the painting by I Fu-chiu, a certificate of authenticity by the chief priest Goshin, and a letter by master Taiga. The person called Bangyoku was the older brother of the calligrapher Kakō Itō Masumichi who lives in Edo. Bangyoku was also called Shūnan and he was a close friend to Goshin; both priests belonging to the same religious sect. My teacher, the deceased Taiga, also wanted very much to have this painting but was not able to acquire it. Never thinking it was possible, I came to own this painting. A most unique work, I have treasured it carefully. Having received your most helpful assistance, I cannot ignore your desire for the painting. Therefore, I am respectfully presenting it to you. Please treasure it as your possession.
>
> Most respectfully yours,
> The twenty-first day of the
> ninth month
> Aoki Shuntō[17]

Shukuya's letter leads to several illuminating points. He tells us of yet another person's desire to own a painting by I Fu-chiu, and he further identifies the priest Shūnan. More significant is the clarification of Katō Yohachi's "most helpful assistance." By examining another letter attending the painting by I Fu-

chiu, the events obliging Shukuya's transferral of *Mount T'ien-t'ai* become apparent.

> Shifū, Taiga's apprentice, needed money. He decided to sell Taiga's twelve Higashiyama paintings for thirty *ryō*. However, the arranged buyer could not pay the price. So, Shifū came to me for assistance. When I was in the capital, I sent my daughter to ask Dr. Hagino if he would buy the Higashiyama paintings. He agreed to buy them for twenty-five *ryō*. At this time, someone from Matsuzaka wanted to purchase the twelve works for thirty *ryō*, so Shifū turned down Dr. Hagino's offer. Later, Shifū somehow became indebted to Dr. Hagino and as a result accepted his twenty-five *ryō* bid. Dr. Hagino asked me to lend him the money to purchase Taiga's paintings, and I did. However, Dr. Hagino became ill and died not having repaid me the twenty-five *ryō*. Shifū took pity on me and so gave me this I Fu-chiu in exchange for the money.[18]

The letter is undated and signed "Dōshō" (Michimasa), but it is clear that Dōshō and Katō Yohachi are one and the same person. The Dr. Hagino mentioned in the text is most probably Hagino Motoyoshi who died in 1806. The letters, then, add to the scarce information concerning Shukuya by providing evidence that he was still alive in 1806.[19]

I Fu-chiu's *Mount T'ien-t'ai* has played many roles through the decades since its creation. At first it served a religious purpose, providing a substitute means for the priest Bangyoku to make his pilgrimage to the Chinese mountain.[20] As such, the painting was valued by the religious community. Artistically, I Fu-chiu's landscape was desired by Nanga artists who regarded it as a valuable model for continental brush modes and compositional methods. Through paintings such as this, I Fu-chiu exerted an influence on several generations of Japanese literati painters. Finally, the letters accompanying the work make it an invaluable documentary source for historians. This recorded evidence for direct relationships between major personages of the early Edo period is an exceptional find. *Mount T'ien-t'ai* proves to be one of the most important paintings by any of the Chinese visitors to Japan.

JW

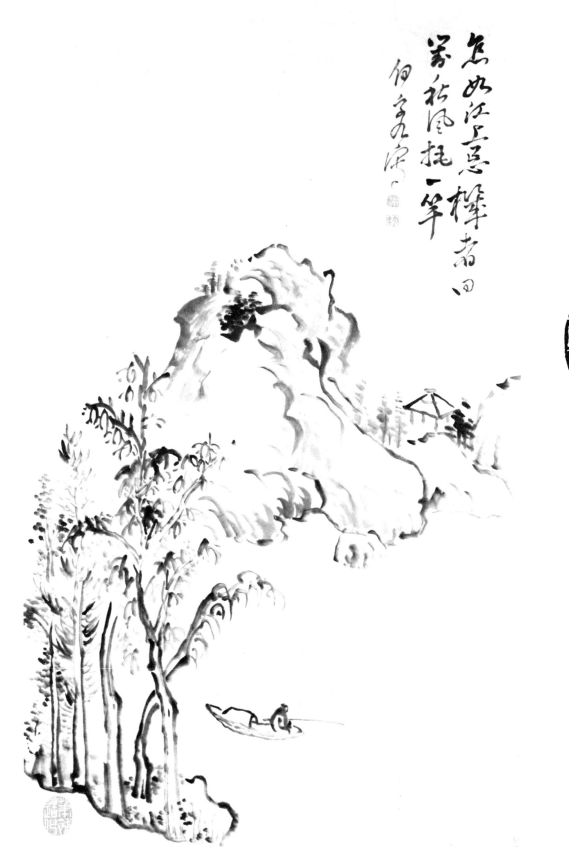

5. Kan Tenju (1727–1795)

Facing the Autumn Wind, after I Fu-chiu
Ink on paper, 57.3 × 34.4 cm.
Signature: Painted by I Fu-chiu
Seals: Kan Tenju, Tenju, Hitsujō zōka (Brush spirit of nature), Seta min?

Kan Tenju came from the Ise area of Matsuzaka, but information on his biography and artistic training is rather elusive. Born Nakagawa Chōshirō, he changed his name to Kan, claiming descent from Korea (pronounced "Kankoku" in Japanese). It is said that Tenju learned brushwork in the manner of the Ming literatus Wen Cheng-ming (1470–1559) and was attracted to Kyoto where he could pursue his interest in Chinese culture.[21] Tenju then devoted his efforts to the study of poetry, painting, and calligraphy, being noted for his proficiency in the latter.[22] In 1741, he met Ike Taiga (cat. 7, 18) and Kō Fuyō (1722–1784); they became fast friends and mountain climbing companions. All three eventually took the sobriquet Sangaku Dōja (Pilgrim of the Three Peaks), having ascended Mount Haku, Mount Fuji, and Mount Asama. *Sangaku kikō* (The Travel Diary of the Three Peaks) of 1760, probably written by Kan Tenju and illustrated by Taiga and Fuyō, records one of these excursions. Diary entries implying that Tenju financed several mountaineering expeditions would indicate that he was rather well-to-do.[23] However, these expenses as well as those incurred through his avid collecting and reprinting of Chinese calligraphy nearly bankrupted him.[24]

Kan Tenju's interest in Chinese models also included painting. Although close to Taiga, Tenju abstained from his friend's often colorful and exuberant brushwork; instead, he preferred to paint with ink alone in a very conservative manner, creating landscapes based on Chinese literati masters. He was among the most ardent admirers of I Fu-chiu, producing numerous copies of his paintings. *Facing the Autumn Wind* is one example of these efforts.

The composition of the landscape is standard: trees, growing on a small area of land on one side in the foreground, extend upward and across an expanse of water, visually unifying the composition by reaching the background hills on the other shore. The brushwork, limited in range of wetness and loosely applied, imitates I Fu-chiu's freer painting style. The broken outlines of the rock forms betray some influence from Taiga, but the texturing and modeling strokes emulate the parallel arcs found in I Fu-chiu's impromptu compositions. Telltale motifs used by the Chinese painter, such as the small hut surrounded by mountain masses and the untextured bark of foreground trees, are also incorporated. The sparseness of the scene and the uniform method of execution suggest the "even and bland" quality admired by Chinese literati and, hence, Kan Tenju.

Unity of poetry and painting was another important factor in literati endeavors. The inscription, a Chinese poem in two lines of seven characters, reflects this harmony between the two arts.

> How can I compare myself to those
> who wander aimlessly on the river?
> Turning my face towards the autumn wind,
> I fish along with my bamboo pole

Even though both I Fu-chiu and Kan Tenju were known for their poetry, it is most likely that this is Tenju's transcription of I Fu-chiu's poem. The symbolic content, a personal desire to be free of mundane concerns, is traditionally associated with literati ideals.

I Fu-chiu embodied the literati canons to which Kan Tenju aspired. By copying I Fu-chiu's works, Tenju not only enhanced his own study of Chinese arts but also bequeathed sources of inspiration to later generations of Nanga painters. In this way, *Facing the Autumn Wind* is at once representative of the general Japanese esteem and of the personal admiration held by Kan Tenju for the Chinese painter, I Fu-chiu.

JW

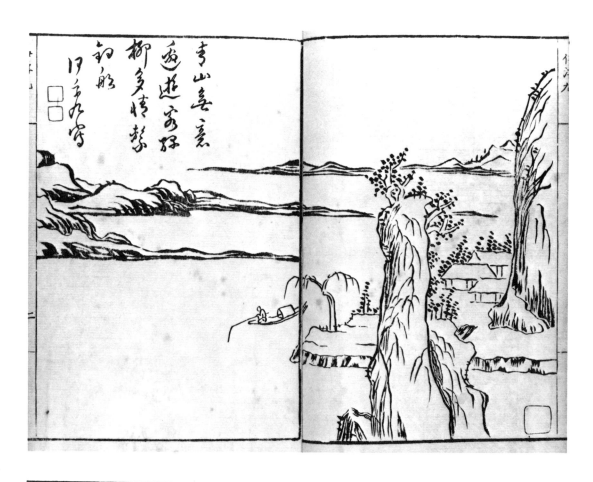

青山喜更佳
遂遊家好
柳多情緒
釣船
伊予乃宅

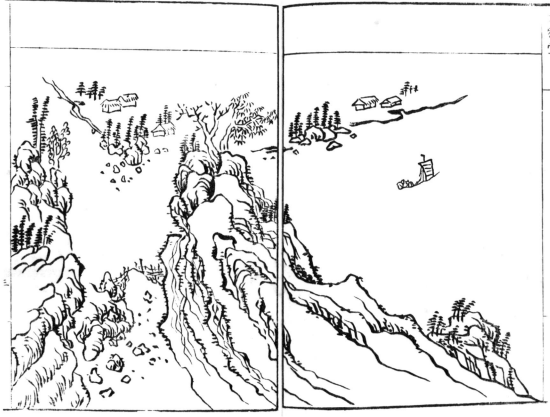

6. Kan Tenju (1727–1795)

I Fukyū Ike Taiga sansui gafu, 1803
Two woodblock books, ink on paper, 26.3 × 17.6
 cm.
Signature: Copied by Kan Dainen at Osaka in 1767
 (vol. 1); copied by Suishinsai Tenju at Osaka in
 1768 (vol. 2)

The widespread popularity of I Fu-chiu was partly due to the publication of the *I Fukyū Ike Taiga sansui gafu* (Album of Landscapes by I Fu-chiu and Ike Taiga) in 1803. Works by the Chinese merchant and one of his greatest admirers, Ike Taiga (cat. 7, 18), are reproduced in two volumes with a single book devoted to each painter. The designs, however, are actually based on copies of the works and not the originals. These copies were part of a group of paintings produced and mounted together in an album format by Kan Tenju in 1767. They were later included in the collection of Kimura Kenkadō (1736–1802), an Osaka sake brewer who became Taiga's student in 1748 and later was a major patron of Nanga painters. Taiga's close relationship with both Kankadō and Tenju guaranteed their acquaintance and so Kenkadō's ownership of these works by Tenju comes as no surprise.

After Kenkadō's death in 1802, the album of copies fell into the hands of Kageyama Takushō (dates unknown), an Edo collector who instigated their reproduction in printed form.[25] He wrote a short foreword praising Tenju's ability in calligraphy and applauding his paintings as "soundless poems."[26] Kageyama also added a revealing note that Tenju regarded his contemporaries I Fu-chiu and Taiga as artists who ranked among the past masters. Kageyama asked two of Tenju's good friends, Nakano Sōdō (1765–1829) and Suzuki Fuyō (1749–1816), to write a preface and a closing note to the two-volume set. Fuyō explained why Kageyama published the compositions; he wanted to share these wonderful works with the public. Sōdō extolled Tenju's calligraphy, describing the high quality of the paintings as a result of Tenju's calligraphic skills.

Volume one contains sixteen landscape compositions based on paintings by I Fu-chiu. *Carefree Wanderer* opens the series with a typical scene of a lone figure who has cast his fishing line into a broad, expansive river. Foreground elements are clustered on the right and are dominated by a tall, narrow pinnacle capped by small bushes. Distant hills reach across the water in three horizontal bands, visually unifying the near and far land masses. A single willow grows on the river bank, spreading its branches over the small fishing boat. The sparseness of landscape elements and the limited range of brushwork exemplify the major characteristics of I Fu-chiu's smaller landscape composi-

tions. Though nearly empty of forms, the landscape is replete with the atmosphere conjured by I Fu-chiu's poem.

> A carefree wanderer seeks pleasure among the blue
> mountains,
> A green willow heightens his enjoyment as he moors
> his fishing boat.

Volume two, subtitled *Taigadō,* is comprised of thirteen works by the leading Nanga master. Many of the reproductions are in fan format and reflect Taiga's bolder and looser painting style.[27] Nevertheless, Taiga's debt to I Fu-chiu can be seen in *Sailing on the River,* a landscape comprised of a few motifs plainly arranged in distinct distances. The repetitive line work is unobtrusive as it builds rock forms, while simple staccato strokes indicate foliage. This "bland" representation supports Kageyama's allegation that Taiga derived his style from I Fu-chiu. The publication of the *I Fukyū Ike Taiga sansui gafu* was not only a singular tribute to I Fu-chiu, Ike Taiga, and Kan Tenju, but its accessibility also made it a major catalyst for the development of their popularity.

JW

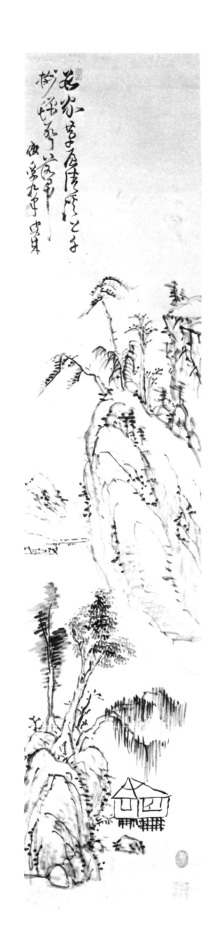

7. Ike Taiga (1723–1776)

Thatched Hut on a River
Ink on paper, 133.5 × 28.9 cm.
Signature: Imitating Fu-chiu by Kashō
Seals: Hekigo suichiku sanbō (Retreat of green
 bamboo and phoenix trees), Arina, Hitsujō
 zōka (Brush spirit of nature), Itsuka issan tōka
 issui (Five days to paint a mountain, ten days
 to paint water)

Ike Taiga's prodigious genius and his unorthodox life-style assured an entry in Ban Kokei's *Kinsei kijinden* (Legends of Eccentrics of Recent Times) of 1790. Taiga began practicing calligraphy at the age of two; by the time he was fourteen he had opened a business in Kyoto supporting his widowed mother. He sold fans he had painted with scenes modeled upon the woodblock pictures in *Hasshu gafu* (Collection of Eight Ming Picture Albums), one of the few manuals imported into Japan during the early Edo period. The shop flourished despite Taiga's unconventional behavior. Once while crossing the Seta Bridge, he threw fans into the water to pay homage to the dragon king.[28] Taiga's proclivity for the unusual is also exemplified in a popular anecdote describing the consternation of his manager who could not read the business accounts because Taiga had written them in an obscure form of seal script.[29]

Within five years, Taiga had expanded his store to include a seal carving shop, reflecting his continual interest in Chinese studies. He would often meet with a group of scholars who studied Chinese calligraphy and Confucian philosophy in addition to Chinese literati painting. He became particularly close friends with Kō Fuyō (1722–1784) and Kan Tenju (cat. 5) who shared his interests, ranging from Chinese studies to mountain climbing. Taiga also associated with members of the Obaku sect, learning more about China and literati painting from the monks at Mampukuji near Kyoto.

Although Taiga's early works clearly follow Chinese prototypes, often using imported manuals as model books, he developed a very individualistic style incorporating Rimpa techniques, bold Zenlike compositions, and "true-view" paintings.[30] His fascination for the formal elements of painting resulted in distinctive landscapes which shimmer with color and calligraphic brushwork. Taiga's creative energy and seemingly endless productivity made him a leading figure among Nanga painters of the eighteenth century.

Thatched Hut on a River illustrates Taiga's admiration for I Fu-chiu, whose works he copied and wished to collect (cat. 4). At the same time, it displays Taiga's idiosyncratic style through his whimsical interpretation. Characteristic motifs such as the foreground grouping of three types of trees, small mountain plateaus, and an empty hut are all evident. However, Tai-

ga has rearranged their relationships by placing the plateau at the very top of the mountain mass and setting the hut on the water next to the bulge of rocks in the foreground. Rather than carefully detailing the various foliage, Taiga rapidly executed calligraphic strokes, contrasting verticals with horizontals and dark ink with light shades of grey. He created an interest in foliage patterns, avoiding representational verisimilitude. Raised on pilings above the water, the hut seems alive in its wiggly outlines and exaggerated roof. The rustic structure leans back as if ready to take a step forward.

The inscription, brushed in Taiga's famous cursive script, is most likely a poem by I Fu-chiu.

> Several thatched huts rest upon the clear river,
> All day long, a thousand wood crickets cry.

Taiga's seal imitates one used by I Fu-chiu (cat. 2); both read "Five days to paint a mountain, ten days to paint water." The seal also suggests an approximate date of 1760 for the painting.[31] Kan Tenju probably owned this work at one time; his seal "Brush spirit of nature" is found in the lower right corner. Taiga's *Thatched Hut on a River* provides further evidence of the popularity of I Fu-chiu's works and even their copies. More significantly, it is an example of Taiga's homage to the source of his inspiration.

JW

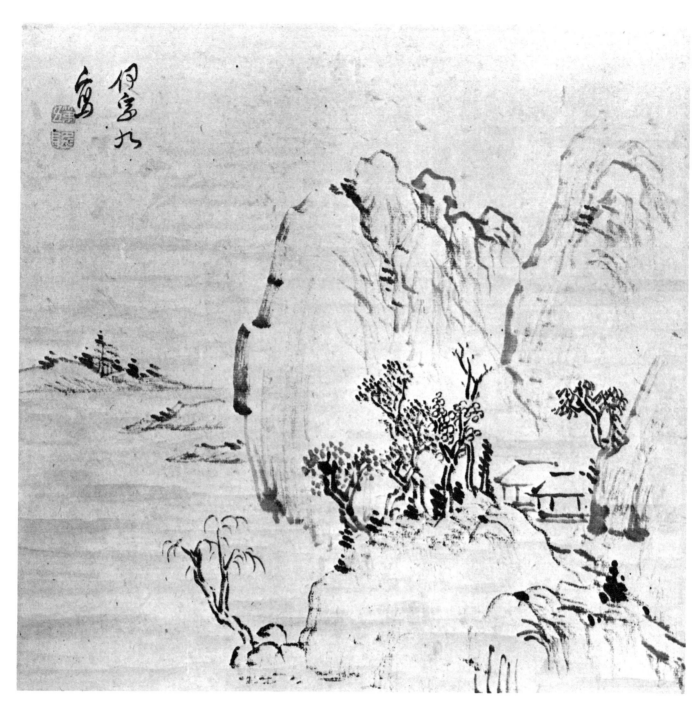

Noro Kaiseki (1747–1828)

Secluded Hermitage, after I Fu-chiu
Ink on paper, 28 × 30 cm.
Signature: I Fu-chiu's painting
Seal: Daigo/ryū

Born into a family who served a Kishu lord, Noro Kaiseki was given the standard Confucian education expected of children in the samurai class during the Edo period. His teacher Itō Rangu (1694–1778), talented in painting ink orchids, also instilled in the young child a love for painting. Pursuing his artistic training, Kaiseki went to Kyoto in 1760 and studied with Obaku Kakutei (1722–1785), learning how to paint in the bird-and-flower tradition introduced to Japan by Shen Ch'uan (cat. 15). On a second trip to the capital in 1767, the twenty-year-old Kaiseki became Ike Taiga's (cat. 7, 18) student, whereupon he "daily produced ten landscapes and formally began his search for authentic Chinese paintings as models."[32] Thus Kaiseki became devoted to literati painting, much like many samurai painters of the later Edo period.[33]

Among the cherished Chinese models sought by Kaiseki were paintings by Huang Kung-wang (1269–1354) and I Fu-chiu. Kaiseki's *Shihekisai gawa* (Shihekisai's Talks on Painting), compiled by one of his disciples after his death, recounts one such attempt to acquire the work of I Fu-chiu.[34] While he was on official business in Matsuzaka, Kaiseki offered to pay ten gold pieces for a landscape triptych by the Chinese painter. However, he was outbid and could only make a copy of the triptych years later, after the work had changed ownership again for the price of thirty gold coins.[35] The story clearly shows Kaiseki's continual pursuit of I Fu-chiu's paintings and indicates that he was not alone in his praise for the Chinese works. Indeed, works by I Fu-chiu were so highly sought that it was rare to find them available.[36]

Secluded Hermitage is an example of an I Fu-chiu imitation by Kaiseki. In a simple composition, the predominant elements are the rock forms which are outlined by a broad, broken line. The outline wavers as Kaiseki applied more pressure to the brush in a halting manner. A few short, dry strokes add texture and solidity to the forms. The diagonal dotting so characteristic of I Fu-chiu's foliage can be seen in the far distant trees and on the outcrop of rocks in the foreground. Even though the application of the diagonal strokes contradicts the natural calligraphic tendency for the brush movement to rise upwards to the right, this type of dotting became a regular feature of Kaiseki's work.

Repetitious strokes and a general lack of strength in the brushwork may indicate that *Secluded Hermitage* is an early attempt by the artist in his pursuit to understand Chinese literati painting techniques. However, Kaiseki was not so much interested in I Fu-chiu's outlines and texture strokes; instead, he attempted to master the high level of I Fu-chiu's spiritual rhythm.[37] The problem of depicting stability in mountain forms and their fidelity to nature became an integral part of Kaiseki's painting theories. Even though he modestly regarded his ability as inferior to that of I Fu-chiu, Kaiseki mastered the "spiritual rhythm" to the extent that his own works were mistaken for those by the Chinese painter.[38]

Kaiseki was Taiga's student, but he sought a different understanding of Chinese literati painting through I Fu-chiu than did his teacher. Kaiseki's works are more reserved and place emphasis not on surface texture but on the relationship of forms. His more conservative style reflects the general trend among third generation Nanga painters in Japan. They preferred to use actual Chinese paintings as models of study rather than the interpretive works of their teachers. This more formal approach to landscapes seemed to be closer to the Chinese literati ideal. Thus, Noro Kaiseki may have felt that this artistic expression was truly appropriate for one who held an official government position, and more importantly, for one who descended from the ranks of the noble samurai class.

JW

扁舟八桨太湖亲
泥迹江湖二十秋
吕炯露泉石亭州
南洲小生画人
壬寅秋日仿写画册
题为
山王敏

9. Inoue Kinga (1732–1784)

Drifting in a Small Boat
Ink on paper, 66.1 × 26.8 cm.
Signature: Painted and inscribed by Kinga for San-
 shi's correction
Seals: Kohon, Junkyō no in, Shin'yō I shi
Published: Stephen Addiss, *The World of Kameda
 Bōsai*, no. 4.

Inoue Kinga was a true scholar-artist. While many of
the most celebrated Nanga masters were forced to be-
come at least partly professional in their painting,
Confucian scholars such as Kinga could turn to brush-
work without thought of patrons, money, or even suc-
cess and failure. Earning his living as a teacher at the
Seijūkan, a private academy in Edo (Tokyo) which
trained many scholars and doctors for the Shogunate,
Kinga occasionally brushed lanscapes with a feeling of
purity and simplicity, derived from the style of I Fu-
chiu.

Drifting in a Small Boat, painted for Kinga's friend
Sanshi (dates unknown), represents a literati vision of
nature and man. A small figure in a fishing boat ap-
pears behind a cliff; he seems lost in contemplation
amid the natural scenery. Almost half of the total sur-
face of the work is taken up by the calligraphy of Kin-
ga's poem:

> Drifting in a little boat with someone intimate,
> The waters of the lake have rippled for twenty
> years—
> I also enjoy the smoky haze from a rocky waterfall;
> Sand bars to the north and south form a road to
> meet my friend.

Following I Fu-chiu, the brushwork of both
painting and calligraphy is modest and relaxed. Rather
than striving for effect, the artist has been able to set
down his feelings easily and naturally. Amid the diago-
nals of boat, cliff, and the curiously shaped mountain,
two central trees anchor the composition with their
strong verticals, continued by the cliff-side, which point
to the calligraphy above. While most of the brushwork
is dry, contrast is achieved by wet horizontal brush
strokes on the trees and wash mountains in the dis-
tance. As in most deliberately "bland" works by I Hai,
the ink tones are predominantly in shades of grey, enliv-
ened by a few darker black accents. Kinga's personal
touch can be seen in the large-scale ease of the calligra-
phy, the dotting confined to the edges of the rocky
forms, and the centralized balance of the asymmetrical
composition.

The act of painting for Kinga must have been a
pleasant interlude to his scholarly work. He was a
leader of a new "eclectic" school of Confucianism in
which his pupils were encouraged to study various
schools of thought, and then to select the best from
each. The freedom that this allowed was stimulating
for students, although it was looked upon with disfavor
by the insular Tokugawa government. Kinga's views,
represented in more than a dozen books including *Kin-
ga sensei keigi setchu* (Kinga's Philosophical Eclecti-
cism), 1764, promoted a new and progressive form of
Confucian philosophy which was carried on by his fol-
lower Kameda Bōsai (see the following entry). How-
ever controversial his teachings, Kinga's personality
was modest, balanced, and refined, as can be seen in
his few remaining artworks. After his death in 1784, a
memorial inscription was written by the physician-
scholar Taki Rankei (1742–1801) which describes
Kinga as "a man above small matters, who liked to
drink wine; no matter how much he drank, his charac-
ter did not change. Entirely harmonious, without sharp
edges in his personality, he resembled the great schol-
ars of ancient times."

By following a style derived from I Fu-chiu, Kin-
ga chose a tradition which came from the great schol-
ar-artists of China, but was simplified to suit the tastes
and abilities of a Confucian literatus. Needing no pub-
lic acclaim for his painting, Kinga could depict nature
with poetic serenity, knowing he would be understood
by a few friends. It could be said that a modest work
such as this, more than major paintings by famous
Nanga masters, best conveys the true Japanese literati
spirit.

SA

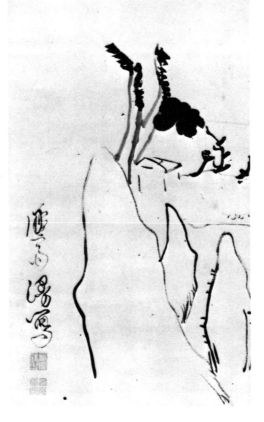

10. Kameda Bōsai (1752–1826)

Mountains in My Heart
Ink on paper, 105.4 × 30.2 cm.
Signature: Uninhibitedly painted by Bōsai
Seals: Bōsai kyōsō (Bōsai the crazy old man),
 Taihei suishi (Peaceful era drunkard)
Published: Stephen Addiss, *The World of Kameda
 Bōsai,* no. 32.

Bōsai, like his teacher Kinga (see previous entry), was a scholar-artist. Usually adding calligraphy and poetry to his paintings, Bōsai followed the I Fu-chiu tradition of simplified depictions of nature derived from the styles of Chinese Yuan dynasty masters. Although Bōsai was known for his great love of wine, his landscapes generally show a restraint and purity of feeling that suggest the artist's sobriety. This work, however, seems quite drunk.

Three spindly cliffs reach upwards to precariously support a plateau with five trees and an empty pavilion. The scene suggests the typical compositions of Ni Tsan, but here the cool and precise world of the Chinese literatus has been turned topsy-turvy. Two little saplings seem to have had their foliage devoured by the tall, leaning, giraffelike tree forms. While a pavilion huddles in a corner of the plateau, the remaining smaller tree butts its wet ink blobs against the sawblade sharpness of its predator. A bare minimum of brushwork conveys the scene, with only a few dots and texturing strokes adding a touch of naturalism to this almost cartoonlike view of nature. Bōsai was indeed uninhibited when he rendered this witty variation upon a most serious literati style.

By his late thirties Bōsai had become an extremely successful teacher, developing the eclectic Confucianism of Kinga, when the Tokugawa government issued an edict denouncing "alien learnings" in 1790. Bōsai's students were forced to study at other schools from which they could hope to obtain government positions, and he was left in his middle years without a profession to follow. He turned to calligraphy, painting, travel, friendship, and wine, becoming one of the most popular scholar-artists of his time. In his later years, Bōsai produced a succession of book prefaces, memorial texts, congratulatory scrolls, landscape designs, and Chinese-style poems. He was particularly noted for his calligraphy in cursive script, influenced by his friend the monk-poet Ryōkan (1757–1831) and deriving ultimately from the style of the eighth-century Chinese "mad monk" Huai-su.

Here the freedom of Bōsai's brush can be seen in every aspect of the scroll's balance between poetry, calligraphy, and painting. This freedom emerged from the true literati spirit of the artist; he had overcome the disappointments that purged his ambition and tem-

pered his idealism. Secure in his individualism, Bōsai was able to paint with both simplicity and humor. The poem that he inscribed on this landscape sums up both his view of painting and his uninhibited character:

> My painting from its inception has had no method,
> How can it be appreciated in this world?
> Merely showing a calm and relaxed feeling,
> It depicts the mountains in my heart.

SA

遠山澗浦

11. Kameda Bōsai (1752–1826)

Kyōchūzan Album, 1816
Woodblock book, ink and color on paper, 27.3 ×
 16.5 cm.
Signature of illustrated leaf: Bōsonkyo
Seal: Bōsai

In Bōsai's later years, he often gathered with artistic friends to talk, drink wine, and exchange impromptu poetry and painting. In the third month of 1816, he was so inspired at one such party that after the other guests had their turns with the brush, he produced a series of landscape designs. One of the guests happened to be a publisher who took the landscape sketches home and resolved to print them. Bōsai may in fact have added to or altered his original designs, but in any case the result was one of the most famous of all Japanese illustrated woodblock books, *Kyōchūzan* (Mountains in My Heart).

Bōsai's simple and evocative painting style, based upon the model of I Fu-chiu, was perfectly suited to the woodblock medium. His landscapes were never complex, and did not require a large number of brush strokes. Instead, he limited the range of his motifs, developed simple but unusual compositions, and relied upon calligraphic brushwork, poetic vision, and soft colors to express his view of the natural world. The carver of the blocks was able to reproduce the effect of actual brushwork, including scumbling effects and the "flying white" where the paper shows through the ink. Bōsai gave each of his small landscape designs a title, signature, and seal, making them the equivalent of album-leaf paintings.

One of the finest of the double-page designs is *Distant Mountains and Spacious Bay.* Two sailboats continue the calligraphic lines of the inscription in the upper left; below them are small twisted trees in similar brushwork. While the lefthand page is relatively empty, the righthand page is filled with mountain forms above a plateau. Growing high on the mountain is a single large tree; above it rests a small pavilion. Human figures are not to be seen, but the sailboats and the pavilion suggest man's presence in this peaceful view of the natural world. The crisp dry brushwork, expertly reproduced in the woodblock medium, the soft colors, and the strong asymmetrical design all show Bōsai's skill in transforming the influence of I Fu-chiu into his own artistic style.[39]

As in the previous painting, Bōsai expressed his inner vision in *Kyōchūzan,* rather than an outward resemblance to nature. In his preface to the book, he noted that he followed no method, but merely depicted scenes within his heart. Stemming from his "shameful drunkenness," they were intended merely for his own enjoyment. In this manner Bōsai rejected worldly values; if others appreciated his work he was delighted, but he did not seek fame, patrons, or public acclaim. He learned his sense of values through his training with Kinga, and then through the difficulties and joys of his life. By expressing his own Japanese artistic vision through the Chinese literati tradition, Bōsai was able to design one of East Asia's most beautiful books.

SA

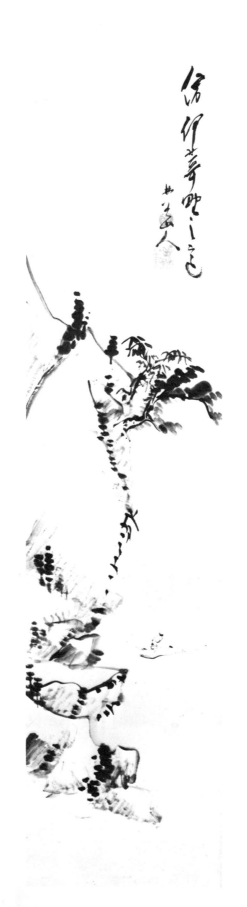

12. Hosokawa Rinkoku (1779–1843)

Landscape after I Fu-chiu
Ink on paper, 117 × 27.3 cm.
Signature: Rinkoku following the idea of I Fu-
 chiu
Seals: ?kyo, Rinkoku sanbōki

Hosokawa Rinkoku was one of the most interesting literati artists of his time, excelling particularly in seal carving but also achieving a personal style in poetry, painting, and calligraphy. He was born in Ishida in Sanuki province on the eastern part of the island of Shikoku, and began studying seal carving in his youth with Abe Ryōzan (1773–1821), only a few years his senior. Ryōzan believed that no art should be isolated from the others, and insisted that his pupils also study Chinese-style poetry with Goto Shikkoku (dates unknown) and Nanga painting with Nagamachi Chikuseki (1747–1806). Rinkoku proved to be talented in all three arts; he also had a fondness for travel, visiting Nagasaki and then moving to Edo, perhaps around the age of thirty. In Edo he was acclaimed as a seal carver, and eventually he was to publish five books of his seal carvings as well as one of his poetry. He visited northern Japan in 1828 and returned the following year, but because of a major fire in Edo Rinkoku journeyed to the west, admiring Mount Fuji and eventually settling in Kyoto in 1831. He became close friends and carved seals for literati masters such as Rai San'yō (cat. 49) and Tanomura Chikuden (1777–1835). Rinkoku was known as a free spirit who loved bamboo, wine, poetry, painting, travel, and friendship; he remains one of the premier seal carvers in Japanese history.

As a painter Rinkoku was a true amateur literatus in the tradition of Kinga (cat. 9) and Bōsai (cat. 10, 11). With free brushwork and bold simple compositions, Rinkoku painted a number of subjects, but preferred bamboo and landscape as his major themes. Considering his background, it is not surprising that he would emulate I Fu-chiu, who set the standard for simple but evocative landscapes in the Chinese scholar-artist tradition. Rinkoku's painting in this lineage is typically relaxed, with seemingly casual brushwork and a subtle range of ink tonalities.

A lone fisherman, or perhaps a scholar in the guise of a fisherman, awaits a bite, ponders philosophy, or searches for poetic inspiration under a cliff in the timeless world of nature. The universality of this image is countered by the freedom of the brushwork, in which the rocks and trees seem to have been depicted with spontaneous abandon. Dotting clings to the edge of the rocky forms; wet strokes of the brush define outline and foliage alike. The lone angler has become one with his surroundings, which lean toward him forcefully and yet sympathetically. Rinkoku has not changed the I Fu-chiu formula for ink painting, but has invigorated it with his own somewhat more dynamic personality. The apparent simplicity of his painting is thus balanced by the individuality of the brushwork.

The two seals bear witness to Rinkoku's special skill in this art form; the second seal, a rare figure study, is particularly unusual and lively in conception. Foregoing the usual ancient "seal script" mode, the characters to the left of the man wielding the brush (a self-portrait?) are carved in regular script, as though they have just been written by the figure. This note of immediacy accords well with the spirit of the painting, which infuses new life into what had now become a standard Nanga convention of following I Fu-chiu. Rinkoku demonstrates the literati tenet that an artist may show his respect for tradition, but his personal character cannot help but be revealed through his brushwork.

SA

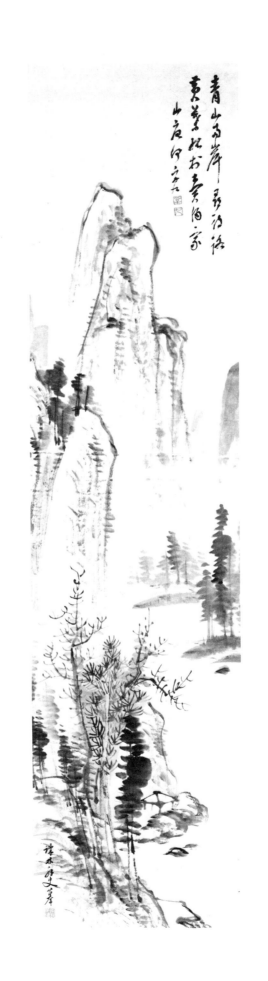

13. Takaku Aigai (1796–1843)

Yellow Leaves and Red Trees, after I Fu-chiu
Ink on paper, 118.5 × 30 cm.
Signature: Sorin Gaishi
Seals: Fu/chiu (painted), Takashi Shien

"First copy the old masters to learn their techniques, then study nature. Go back to the old masters and discern the differences. Now, paint your own landscapes using the 'image idea' of the masters."[40] Such was the training method said to be taught by the Edo painter Tani Bunchō (1763–1840) and thus learned by his student, Takaku Aigai. For Aigai, this "image idea" evoked by nature and found in the works of Chinese literati became an important artistic goal.

> The mountain faces of green peaks pose a poetic
> passage:
> A wine shop amid yellow leaves and red trees.
> I Fu-chiu from Shant'ang

The inscription which includes the signature and seals of I Fu-chiu suggests that Aigai was making a direct copy. Rising crags flank a deep valley, while a secluded hut is barely noticeable among the trees which line the river banks. Distant peaks are formed by ink wash alone, but the main mountain masses are delineated by blunt strokes of wet, grey ink and modeled with dry, oblique strokes accented by horizontal dots. In varying degrees of ink tones, these dots are echoed and stressed as tree foliage which seems to reflect the sunlight. In turn, Aigai's ink shades create a visual effect that elicits the colorful "image idea" of I Fu-chiu. The limited range of brushwork and motifs also alludes to the Chinese master. Yet, Aigai's artistic training led him to other expressive avenues.

Takaku Aigai became Bunchō's student in 1823. However, Aigai had earlier received lessons in calligraphy and academic style painting from scholars of the Kanuma area near his home province of Shimono. At the age of twenty-three, he began to seriously study painting and Chinese writing under Suzuki Shotei (1777–1831), who collected and researched the works of I Fu-chiu. Shotei was highly impressed with Aigai's paintings; he provided Aigai with many introductions to local scholars and prospective buyers. Shotei also accompanied Aigai on his first trip to Sendai where Aigai spent his time visiting Japanese collections of Yuan and Ming dynasty paintings.[41] Through this network of acquaintances, Aigai eventually met Kikuchi Tanga (1789–1854), a wealthy merchant from Nihonbashi in Edo. Tanga became a very important figure who, like Kimura Kenkadō (1736–1802), was a major patron of the arts amassing a collection of over two hundred paintings. Just as significant is the fact that he was the center of a literati circle which included Yamamoto Baiitsu (cat. 37, 48), Watanabe Kazan (1793–1841), Tachihara Kyōsho (1785–1840), Tsubaki Chinzan (cat. 23), and Tani Bunchō.[42]

Aigai studied with Bunchō for five years, becoming an intimate member of the Tanga circle. Each time Aigai made a trip to Sendai or the Kyoto-Osaka area, he copied the Chinese works he saw. Many of these copies entered Tanga's growing collection. Like Bunchō, Aigai produced works in numerous artistic traditions: bird-and-flower paintings in the realistic style of Shen Ch'uan (cat. 15), portraitlike figure paintings in the manner of Kyōsho, and landscapes after the great Chinese masters of the Sung through the Ming dynasties.

Unlike his teacher Bunchō, however, Aigai sometimes followed the brushwork of Ike Taiga (cat. 7, 18). The works of Aigai's early forties exhibit a large debt to the Kansai master. *Yellow Leaves and Red Trees* falls within this corpus of Aigai's landscapes. The subtle variations of ink tonality, particularly in the dotting, emphasize the surface and negate depth. The blunt outlines are freely executed as are the broad sweeps of wash. Both of these characteristics can be found in Taiga's landscapes.

During the late 1830s Aigai began signing his paintings Sorin Gaishi. Most likely, the signature reflected his close ties to the group supporting Watanabe Kazan. He became deeply involved in the efforts made to rescue Kazan from prison, and along with other members of the movement used the sobriquet, Gaishi. Thus, *Yellow Leaves and Red Trees* may be dated to the last years of Aigai's life. Just two years after Kazan's suicide, Aigai died of a stroke at the age of forty-eight, suddenly ending the career of a very active Nanga painter who played a role in disseminating the "image idea" of I Fu-chiu to Edo.

JW

41

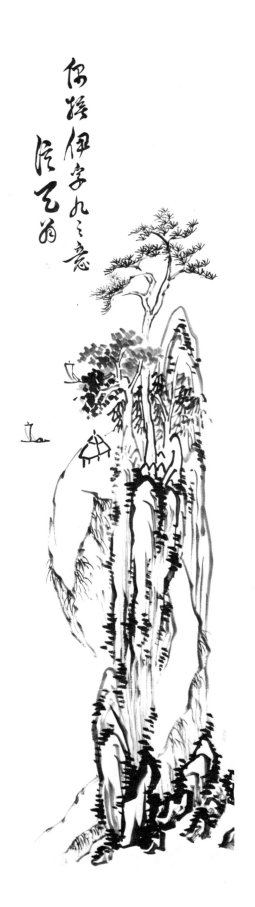

14. Yamanaka Shinten'ō (1822–1885)

Casually Embracing I Fu-chiu's Idea
Ink on paper, 110 × 30.1 cm.
Signature: Shinten'ō
Seals: Seiitsu, Shinten, Tōkinkan

My paintings belong to no school.
I simply take mountains and river and make them
 brush strokes.
I take clouds and smoke and make them ink wash.
I paint a place to live, a place to wander, a place
 where my spirit resides.[43]

Who could better describe the works of Yamanaka Shinten'ō than the artist himself? Certainly, his often strange and distorted landscapes reject visual analysis in any traditional form. Here, the mountain mass dynamically comes to life like a scraggly beast rising on its haunches. Distant sails and firmly implanted trees stabilize and calm this rising surge. The old pine splays its branches, crowning the crest and lending a majesty dignity to the awakened creature. Shinten'ō's bold and wet oblique strokes defining the lower forms propel the eye up toward the more blunt and grey brushwork of the rock walls. Outlines ripple in deliberately awkward movements of the brush. When we look at the twisted rock forms spiraling their way upwards, the plateau wrenched precipitously downward, and the hairlike appendages growing off the edges of the flattened areas, we do not see empirical forms from nature; instead, we see its life force, the natural motivation of the artist's inner spirit.

Shinten'ō was born into a Mikawa family which served the imperial line. As a result of this ancestral heritage and because of his fervor for Western social theories which were bombarding late nineteenth-century Japan, he took part in loyalist movements promoting the return of political power to the emperor. Among his loyalist compatriots were other artists like Rai San'yō (cat. 49) and Fujimoto Tesseki (1817–1863). After spending several years in service to imperial princes, Shinten'ō became a basically self-taught painter and calligrapher; his studies were less of works themselves than of their underlying theories. Among his several antiquarian collections were books of Ch'ing dynasty painting theories such as the *Ch'ing Ming chia lun hua chi* published in 1861.[44] He pored through these texts, and searched for others whenever he made trips to Kyoto, Osaka, or Nagasaki. These journeys also provided opportunities to see actual Chinese paintings such as *Stone Cliff at the Pond of Heaven* attributed to Huang Kung-wang.[45] Yet, as frequent as these trips

were, Shinten'ō always returned to his beloved countryside, the residence of his inner spirit.

Although his bold forms and blunt brushwork are characteristic of Meiji style, Shinten'ō's expression is unlike that of his fellow artists. His paintings continuously reflect the "image within his breast."[46] In this hanging scroll, Shinten'ō captures the dynamic essence of nature residing within his spirit, and at the same time casually embraces I Fu-chiu's idea of "spiritual rhythm." Shinten'ō also makes use of the Chinese painter's characteristic motifs, diagonal dotting for foliage and a small empty hut safely nestled on a plateau between rising mountain forms. Shinten'ō's idiosyncratic nature, however, transforms the foliage dots into accents of rocky crevices and the hut tilts dangerously on the twisted plateau.

Shinten'ō was not a technically proficient painter. Like a true literatus, he dabbled in many arts including calligraphy, Chinese and Japanese poetry, pottery, and painting but never attained a complete professional mastery in any one of them. Yet, this amateurish quality is what appealed to many connoisseurs who were caught in the wave of nationalist loyalism during the later Meiji period. Native spirit was paramount, and Shinten'ō could not be surpassed in this inner personal vision.

JW

Notes

1. The Wu school, traditionally said to have been founded by Shen Chou (1427–1509), included a group of scholar-amateur painters who were centered around Su-chou during the Ming dynasty (1368–1644). Wang Shih-min (1592–1680), Wang Chien (1598–1677), Wang Hui (1632–1717), and Wang Yuan-ch'i (1642–1680) were orthodox painters whose art was based on stock motifs and standard compositions following the precepts of the Ming theorist Tung Ch'i-ch'ang (1555–1636).

2. Tsuruta Takeyoshi has painstakingly researched each of these visits and enumerates them in "I Fukyū to Ri Yōun," 18–19.

3. Umezawa Seiichi, *Nihon nanga shi*, 285–286.

4. Reproduced in *Bijutsu kenkyū* 97 (January 1940): plate IV.

5. Tsuruta, "I Fukyū to Ri Yōun," 19–20.

6. These remarks were made in Gyokushū's *Kaiji higen* of 1799 and Chikuden's *Sanchūjin jōsetsu* of 1813; see also Tsuruta, "I Fukyū to Ri Yōun," 16.

7. This composition closely imitates the arrangement of motifs found on the right section of I Fu-chiu's triptych, *Rigō sansui*, reproduced in *Bijutsu kenkyū* 97 (January 1940): plate IV.

8. Tsuruta, "I Fukyū to Ri Yōun," 21.

9. Tsuruta, "I Fukyū to Ri Yōun," 19.

10. On this trip, I Fu-chiu arrived at Tsushima in 1741, having been blown off course by a sea storm. His boat had to be towed to Nagasaki, reaching the port city in the second month of 1742.

11. The information concerning Shūnan's visit with I Fu-chiu was culled from an undated letter signed Dōshō which accompanied the scroll but is not mounted.

12. I have slightly modified Joseph Seubert's translation of this poem. Shih Ch'iao-ts'un mountain is in Che-chiang province and can probably be seen from Mount T'ien-t'ai. The phrase "on the middle plateau" may imply the achievement of enlightenment since it refers to the central image of a Buddhist triad which is often the image of Buddha.

13. I am very grateful to Iwasaki Tetsushi who provided transcriptions of the letters, most of which were written in difficult cursive script. I would also like to express my appreciation to Joseph Seubert for his annotated translations of all the letters belonging with this scroll. The excerpts cited in the text are modified versions of these preliminary translations; I have omitted salutations, closings, and other irrelevant information.
 The use of "Jō" before Goshin's name may indicate the temple to which he belonged. Bangyoku, too, used the word in another of his names, Jōju, as mentioned in a letter signed "Suiboku." Goshin's seals read, "Genmyō no in" and "Goshin-min."

14. I Hsin-ye is one of the artist names used by I Fu-chiu.

15. Melinda Takeuchi, "Ike Taiga," 171. The inclusion of "jō" in the priests' names may refer to the Jōkōji, Taiga's family temple in Funaoka.

16. Shūhei is a sobriquet used by Taiga. The statement expressing his desire to own *Mount T'ien-t'ai* seems to have been an afterthought, but it does indicate that Taiga did not ever actually own this painting. Ichiuan is the name of a hermitage that Goshin had built in Kyoto; he then took its name as yet another of his sobriquets.

17. Itō Masumichi (1709–1776), also known as Kakō, was originally from Ise but worked in Edo. Shuntō is one of Shukuya's artistic names; his seal reads, "Shukuya."

18. Not all of the letter has been cited here; information that repeats that in previous letters has been omitted. Shifū is an artistic name used by Shukuya. The "someone from Matsuzaka" may well have been Kan Tenju (cat. 5), who did one of the box inscriptions for this painting.

19. According to Joseph Seubert, this is the same Hagino Motoyoshi (1737–1806) for whom Taiga painted his *Twelve Scenic Views of Japan*. See Matsushita Hidemaro, *Ike Taiga* (Tokyo: Shunjūsha, 1967), 152 and *Ike Taiga sakuhin shū* (Bijutsu Shuppansha, 1960), plate 450. Although Shukuya was one of Taiga's major pupils, very little is known about him, including his date of death.

20. The original function of I Fu-chiu's painting can be compared to the numerous Mount Fuji mandalas of Kamakura Japan. Images of Mount Fuji were created in order that worshippers who could not make the actual journey to the sacred mountain would be able to experience the pilgrimage by meditating upon the paintings.

21. Umezawa Seiichi, *Nihon nanga shi*, 363.

22. Kan Tenju is usually recorded in dictionaries and biographies as a calligrapher. He is found in the calligraphy section of the Meiwa 5 (1768) *Heian jimbutsu shi*.

23. Suganuma Teizō, "Taiga no sangaku kikō," *Bijutsu kenkyū* 73 (January 1938): 9–27.

24. Melinda Takeuchi, "Ike Taiga," 152.

25. Tsuruta Takeyoshi, "I Fukyū to Ri Yōun," 20.

26. The phrase "soundless poems" is an indirect reference to the paintings of Wang Wei and Han Kan as written by the well-known literatus Su Shih (1037–1101). See Susan Bush, *The Chinese Literati on Painting: Su Shih to Tung Ch'i-ch'ang* (Cambridge: Harvard University Press, 1917), 25. The phrase indicates paintings that have the true literati spirit.

27. Four images on pages nine through twelve of the second volume are reproductions of album paintings in the Mary and Jackson Burke Collection, New York. Murase Miyeko surmises that Taiga completed the original paintings in 1760 after a mountain climbing excursion with Kan Tenju (cat. 5) and Kō Fuyō. In her essay, Murase refers to the editor Kageyama Takushō as Nakazawa Kyūbi. See Murase Miyeko, *Japanese Art: Selections from the Mary and Jackson Burke Collection* (New York: The Metropolitan Museum of Art, 1975), 243–248.

28. Ban Kōkei, *Kinsei kijinden*, 154.

29. Melinda Takeuchi, "Ike Taiga," 152.

30. For more on Taiga's "true-view" paintings, see Melinda Takeuchi, "Visions of a Wanderer: The True View Paintings of Ike Taiga" (Ph.D. Dissertation, University of Michigan, 1979).

31. Melinda Takeuchi, "Visions of a Wanderer: The True View Paintings of Ike Taiga" (Ph.D. Dissertation, University of Michigan, 1979).

32. A detailed study of Kaiseki's biography can be found in Mori Senzō, "Noro Kaiseki den no kenkyū," parts 1, 2, and 3, *Bijutsu kenkyū* (1937–1938): vol. 71, pp. 26–35; vol. 72, pp. 6–16; and vol. 74, pp. 21–27.

33. For more on samurai painting, see Stephen Addiss and G. Cameron Hurst, *Samurai Painters* (Tokyo: Kodansha International, 1983).

34. "Shihekisai gawa," *Bijutsu kenkyū* 75 (March 1938): 152.

35. The man who outbid Kaiseki may have been Kan Tenju, as surmised by Wakita Hidetaro in "Noro Kaiseki no kenkyū," *Kokka* 924 (1970): 11–12. The triptych in question is now in the collection of Hasegawa Jirobei, Matsuzaka, and is illustrated in *Bijutsu kenkyū* 97 (January 1940): pl. IV.

36. Wakita Hidetaro in "Noro Kaiseki no kenkyū," *Kokka* 924 (1970): 11.

37. "Shihekisai gawa," *Bijutsu kenkyū* 75 (March 1938): 151. The translation of "spiritual rhythm" was rendered by Hugh Wylie, Royal Ontario Museum, Toronto, in an unpublished manuscript.

38. "Shihekisai gawa," *Bijutsu kenkyū* 75 (March 1938): 151.

35. For further designs from this book and a discussion of related paintings, see Addiss, *The World of Kameda Bōsai*, 64–72.

40. Ueno Tadashi, *Takaku Aigai ten*, 5.

41. Ueno Tadashi, *Takaka Aigai ten*, 7.

42. Ueno Tadashi, *Takaka Aigai ten*, 6.

43. Furukawa Shū, *Nanga ronsui*, 248.

44. Furukawa Shū, *Nanga ronsui*, 246.

45. Furukawa Shū, *Nanga ronsui*, 240. *Stone Cliff at the Pond of Heaven* was also seen by Noro Kaiseki (cat. 8) as recorded in *Shihekisai gawa*, 150.

46. Furukawa Shū, *Nanga ronsui*, 249.

Part Two: Bird-and-Flower Painting

Three main trends in bird-and-flower painting were influenced by Chinese visitors during the Edo period. The first was the decorative and "realistic" style introduced by Shen Ch'uan (active 1725–1780) in the early eighteenth century. This style became so widespread that the literatus Tanomura Chikuden (1777–1835) could write in his *Sanchūjin jōsetsu* (Chitchat of a Mountain Hermit) of 1813 that:

> Today's painters, when depicting birds and flowers, usually follow the "boneless" technique that was made popular by Shen Ch'uan. . . . he painted with adroit contours and his pigments were thick and charming. During these times of protracted peace, people had become tired of the Sesshū and Kano schools, so everyone praised Shen and his style advanced quickly. Shen passed on his techniques to Yūhi of Nagasaki, who thereupon taught Sō Shiseki of Edo.

Shen Ch'uan's style had roots in academic bird-and-flower painting of the Ming dynasty, but may also have been influenced by Western techniques introduced to China by Jesuit missionary artists. For example, Shen achieved a sense of three-dimensional volume when painting rocks and trees by shading the forms on the edges while leaving their centers light; he also depicted the bird and flower motifs with almost botanical accuracy. Rather than a true "boneless" style (without any outlines), Shen usually painted in a "hidden outline" technique where color was added over the delicately painted outlines so that the lines themselves were nearly invisible. This was in contrast to the Kano school style of painting which utilized strong outlines to define plant, bird, and animal forms.

Shen's style did indeed become very popular in Japan, and through Kumashiro Yūhi (1693 or 1713–1772) and his pupils it quickly spread to the major artistic centers of the country. The Nagasaki school was to influence artists of many kinds, including major figures of the Rimpa, Nanga, and Maruyama-Shijō traditions. Other Chinese visitors such as Chang K'un (circa 1744–after 1817) came to Nagasaki with more literati styles, but they too were asked for colorful bird-and-flower painting in the Shen tradition. A long-standing question as to whether Chang K'un was the same artist as the decorative master Chang Hsin may be helped to resolution by works in the Hutchinson collection.

The second style of bird-and-flower painting to reach Japan was quite different in spirit and subject matter. This was the revival of "four gentlemen" painting, devoted to the ink-play subjects of bamboo, plum, orchid, and chrysanthemum. A purely literati tradition, this had been known previously in Japan but was given a new impetus by the arrival of the Obaku sect Zen monks, who were excellent calligraphers and also painted "four gentlemen" subjects on occasion. Monk-artists such as Obaku Ta-p'eng (1691–1774) developed individual styles of painting that were of interest to Nanga masters such as Ike Taiga (1723–1776), who transformed his models with remarkable creativity. These "gentlemanly" ink-play subjects continued to be popular throughout the Edo and Meiji periods, particularly with scholar-artists who practiced the "three treasures" of painting, poetry, and calligraphy.

The third style of bird-and-flower painting to reach Japan was the Ch'ing dynasty refinement of decorative techniques as exemplified in the works of Yun Shou-p'ing (1633–1690). Although Yun himself did not leave China, his style became known in Japan through the works of other artists as well as by the importation of paintings in his technique. Yun's style combined some of the decorative values of past bird-and-flower painting with a literati touch. His brushwork was refined, his colors often subtle rather than brilliant, and he was also a fine calligrapher who was able to add poetry to his compositions to give them a scholarly flavor. Yun also utilized a true "boneless" technique, allowing the spreading ink and colors to achieve their own freely shaped forms without the constriction of outlines.

Yun Shou-p'ing's refined bird-and-flower style had a gradual impact in Japan, sometimes being combined with Shen Ch'uan techniques and eventually supplanting the earlier master's influence. Nanga artists such as Tsubaki Chinzan (1801–1854) and Taki Katei (1830–1901) developed their own versions of Yun's "boneless" style, producing paintings that combined attractive subject matter with literati values such as expressive individual brushwork and poetic sensibility. As so often happens in Japanese cultural history, native artists made new combinations of traditions that had been kept distinct in China. Academic and literati influences were often mixed together with the Japanese preference for dramatic asymmetrical compositions and evocative brushwork. This led to a new form of bird-and-flower art that owed much to China, and yet was fully expressive of the Japanese spirit.

SA

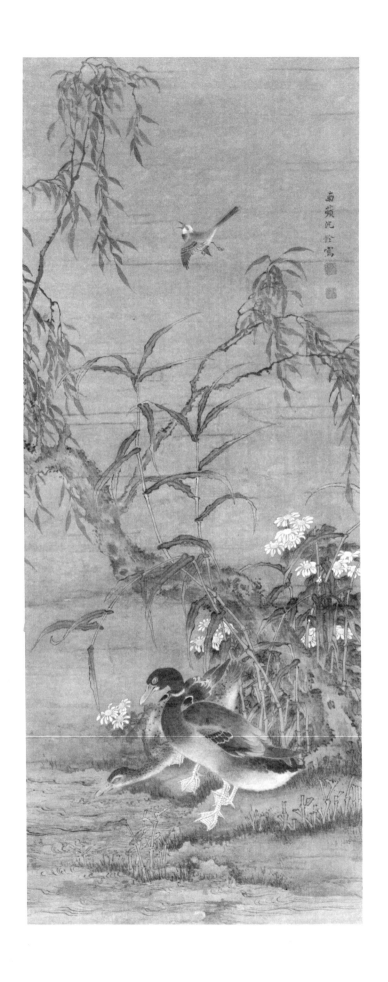

15. Shen Ch'uan (J: Chin Nanpin, active circa 1725–1780)

Ducks in an Autumn Scene
Ink and colors on silk, 48.4 × 117.7 cm.
Signature: Painted by Nan-p'in Shen Ch'uan
Seals: Shen Ch'uan, Heng-chai,[1] ?

A tendency in Chinese bird-and-flower painting toward greater naturalism, possibly influenced by the West, culminated in the work of Shen Ch'uan (also known as Shen Nan-p'in). His detailed compositions with meticulous brushwork and opulent colors appealed to Japanese taste and had a strong influence upon artists of various schools during the Edo period. Painters such as Shen's direct pupil Yūhi (cat. 16) and Yūhi's many disciples carried Shen's realistic, decorative manner throughout Japan.

Shen Ch'uan was a Ch'ing dynasty professional bird-and-flower painter. A native of Wu-hsing in Che-chiang province, he was invited by a high official to Japan. He may have been expected to transmit Sung and Yuan dynasty painting styles, but instead he introduced late Ming techniques, possibly influenced by the West, leading to a new form of "realism." He arrived in Nagasaki, probably with two of his pupils, in the final month of 1731. His works became so popular that even after he returned to China in the autumn of 1733 he continued to send his paintings to customers in Japan.

This painting suggests an intimate world of nature in autumn. The ground plane, indicated with a few light brush strokes, is surmounted by grasses and broken reeds. Most of the elements are depicted in the "boneless" style,[2] except for the taller reeds, which are outlined with sharp strokes in a discontinuous line characteristic of earlier Chinese bird-and-flower painting. A shallow sense of depth is created from the ducks in the foreground to the chrysanthemums in the middleground; the background is left undefined.

The trunk of the willow, running diagonally across the entire composition, is freely painted with wet brush strokes, light wash, and grey dotting. The edges of the trunk are rendered in darker tones than the center, giving the illusion of a three-dimensional rounded form. In contrast, the willow leaves, reeds, and chrysanthemum petals are all individually painted with great care. In comparison to the volumetrically rendered tree trunk, the compact strokes of the leaves convincingly define their graceful shapes. The depiction of the rippling water in the lower left perfectly complements the tensely animate world of nature. Shen's careful drawing of the ducks at the foot of the gnarled willow, and the little bird flying above, demonstrates his decoratively "realistic" style that was to become a major influence in Japan.

LL

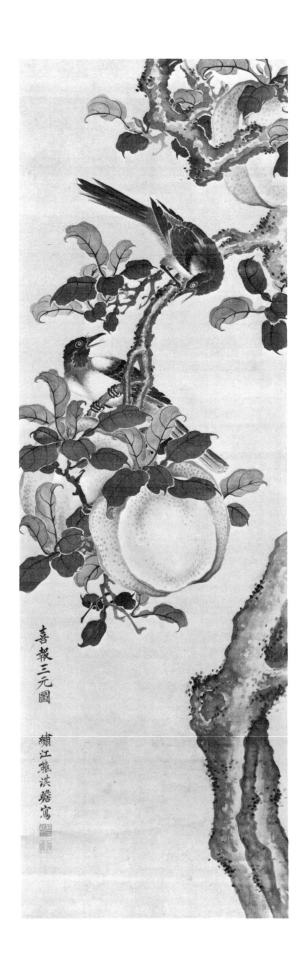

喜報三元圖

浙江華洪曙寫

16. Kumashiro Yūhi (1693 or 1713–1772)

Magpies Report Three Joys
Ink and colors on silk, 112 × 36.6 cm.
Signature: Painted by Shūkō Yūkisen
Seals: Yūhi in, Kisen

As the chief student of Shen Ch'uan in Nagasaki, Kumashiro Yūhi became the most important artist and teacher of the new bird-and-flower style of painting. The son of a Chinese-language interpreter, Yūhi studied assiduously with Shen upon the Chinese master's arrival in the port city. Judging from Yūhi's great skill, he may have also studied with Shen's Chinese students who accompanied their master and then lingered in Nagasaki after Shen's return to China. Although there is not a great deal of written information about him, it is clear from his paintings that Yūhi not only mastered Shen's techniques, but also began the process of transforming the style to suit Japanese sensibilities.

Magpies Report Three Joys follows the lead of Shen in being both a highly decorative painting and also having symbolic congratulatory meanings. The "three joys" of the title, literally "three origins," refer to the three large round fruits, probably a species of persimmon, on the tree. However, the "three origins" can also refer to the New Year, the first day of the first month, and even more specifically, to the passing of the three examinations in China. Thus the connotations are those of success and joy.

The composition exemplifies the Nagasaki school style of bird-and-flower painting. A branch of a tree begins in one lower corner, twists out of the composition and reappears above, creating a space cell in which the main motifs of the painting are featured. Here we see two magpies in animated poses; perhaps they are "reporting" to each other that they have discovered the three large fruits. Another typical feature of the Nagasaki school is the sense of volume conveyed in the trunk and branches of the tree by utilizing short grey strokes and wash on the edges of the forms while leaving the center of the trunk light. Clusters of dots reinforce this impression of roundness, while more exacting brushwork describing the birds and fruits gives a "realistic" tone to the painting. Most skillful of all is the handling of the leaves. Rendered in varied tones of grey, they are enlivened by hooking lines which indicate their veins. These energized brush strokes keep the scroll from any danger that the decorative effects might leave a stilted impression.

Yūhi has not merely transmitted Shen's style in this scroll, he has also anticipated the direction that Nagasaki painting took in the hands of later artists.

First, he has brought the details of the composition to the foreground; instead of a foreground and middle-ground view, as in many of Shen's works, we have a close-up look at the major motifs of the painting. Second, Yūhi has simplified and dramatized the brushwork style that he learned from the Chinese master. While Shen tended to build up forms with an accumulation of short strokes, Yūhi has used fewer and larger brush strokes and more wash. Third, he has renounced any interest in creating a sense of depth beyond the volumetric rounding of the tree trunk and branches; there is no feeling of recession in space. Finally, he has simplified the composition by focusing on a few motifs, eliminating all extraneous elements from the painting.

The importance of Yūhi as a painter was matched by his significance as a teacher. His followers spread the interest in Nagasaki-style painting all through Japan. Sō Shiseki (1712–1786) took this tradition to Edo, and the Obaku monk Kakutei (1722–1785) popularized it in Kyoto and Osaka;[3] eventually this style became widespread among artists of many different schools. Although it was gradually supplanted by newer bird-and-flower traditions from China, the Nagasaki school of painting as transmitted by Yūhi became an important influence upon Japanese decorative painting of the middle Edo period.

SA

17. Obaku Ta-p'eng (J: Taihō, 1691–1774)

Bamboo
Ink on paper, 133.5 × 59.6 cm.
Signature: Brushed by Hsiao Weng P'eng
Seals: Ta-p'eng shih yin, Shih Cheng K'un shih
Published: Stephen Addiss, *Obaku: Zen Painting
 and Calligraphy,* no. 36.

Among the most influential immigrant Chinese artists in Japan were the Obaku Zen monks, many of whom were gifted in calligraphy and "four gentlemen" painting of bamboo, orchid, plum blossom, and chrysanthemum. Loyal to the Ming cause, these monks came to Japan after the fall of the dynasty in 1644 from Fuchien province in southern China.[4] At first, like all Chinese immigrants, they were restricted to Nagasaki, but in 1659 they were given special permission to build Mampukuji, a major temple complex outside of Kyoto in the mountains of Uji.

Although they were followers of Lin-ch'i (Rinzai) Zen, the Chinese monks were considered a new sect in Japan, which became known as Obaku. Their practices were different from those of Japanese monks in both form and substance. For example, they chanted sutras in a Chinese style, wore sandals inside the temple halls, drank steeped rather than whisked tea, and combined elements of Pure Land Buddhism, such as calling on the name of Amida, with their Zen teachings. Most significantly, they brought to Japan the culture of the late Ming dynasty, including painting, poetry, and calligraphy.

For over a century after the first arrival of the Obaku monks, an immigrant Chinese was chosen to be patriarch of the sect and abbot of Mampukuji. Ta-p'eng, who had become a monk at the age of fifteen in China and emigrated to Japan in 1722, became the fifteenth abbot in 1745. He retired from this post after three years, but was persuaded to once again assume the abbotship ten years thereafter, becoming the eighteenth abbot. He again retired in 1765 and died ten years later.

Unlike many of the Obaku monks whose paintings derived directly from their skill as calligraphers, Ta-p'eng was a specialist in the painting of bamboo. His style was unique, consisting of contrasts between clumps of criss-crossing leaves and single leaves flying off their twigs. When painting upon silk, Ta-p'eng often suggested snow by carefully filling in grey wash near the leaves; on paper, his brushwork was more rapid and spontaneous. This scroll was originally one from a set of four quite similar paintings, each displaying the artist's distinctive brushwork and compositional strength.[5] Here, Ta-p'eng's typically thick bamboo culm angularly twists upwards while leaves echo the diagonal movement downwards. Varieties of ink tones are subordinated to bold black slashes of the brush; "flying white," where the paper shows through dry brushwork, gives a suggestion of tonality. The resulting strong and commanding presence is lightened by the fact that many of the individual leaves and twigs do not touch each other. This imparts an airiness which is heightened by the large amount of empty paper at the top of the scroll.

Ta-p'eng's style of bamboo painting was continued by his Zen follower Raihō, and also influenced a number of Nanga artists including Gion Nankai (1676–1751), Ike Taiga (see the following entry) and Kuwayama Gyokushū (1746–1799). Although the Obaku monks very seldom painted landscapes, they were particularly influential in Japan for their calligraphic styles and for "ink-play" subjects such as this *Bamboo.* The special position accorded Obaku monks in Japan, where their sect achieved great popularity in the late seventeenth century, encouraged a new wave of literati culture. Although the Zen teachings of monks such as Ta-p'eng were never to become dominant in Japanese religion, their cultural and artistic impact left a lasting mark in their new country.

SA

18. Ike Taiga (1723–1776)

Bamboo Endures the Frost
Ink on paper, 130.8 × 28.5 cm.
Signature: Brushed by Kyuka Sanshō
Seals: Sangaku Dōja, Ike Mumei in
Published: *Ike Taiga sakuhin shū,* Tokyo: Chūō
 Kōron, 1960, plate 246.
Stephen Addiss, *Nanga Paintings,* no. 7.
Howard Link, ed., *Asian Orientations.*

Were it not for the extraordinary force of his artistic personality, Taiga would be classified as an eclectic painter. He drew on a wide range of Chinese and Japanese sources but was able to transform them through the power of his imagination and the creative strength of his brushwork. His works express sheer joy in manipulating brush and ink; there is an amazing vitality to his surviving oeuvre, from the age of two when he brushed the words "Kinzan," until the end of his life.

With his enjoyment of calligraphic brushwork, it is not surprising that Taiga excelled in the "four gentlemen" ink-play subjects. He particularly favored bamboo, which he painted often in a variety of styles. As a young child Taiga had been taken to the temple of Mampukuji, where he delighted the monks with his prowess in calligraphy. In return, he was influenced by the brushwork of the abbot, Obaku Ta-p'eng (see previous entry). Many of Taiga's depictions of bamboo show the criss-crossing and occasionally flying leaves that characterize the style of Ta-p'eng, but in Taiga's hands these motifs were simplified and dramatized in a thoroughly Japanese manner.

In this work of Taiga's maturity the influence of Ta-p'eng has been almost completely assimilated. There is a suggestion of criss-crossing in the leaves, and a few larger leaves appear to fly off their twigs. However, the entire composition has been brought closer to the pictorial surface, there are fewer elements, and a new emphasis has been placed upon variety of ink tones. Most literati artists, following calligraphic training, held their brushes perpendicular to the paper or silk. Taiga perfected a manner of painting bamboo with his brush held at an angle, the tip dipped in black ink while the body of the brush hairs was suffused with grey ink. This allowed him a range of ink tones within a single brush stroke, suggesting the play of light upon the bamboo leaves. Within the scroll's simple and dramatic composition, this produces a subtle effect. The leaves reach upwards towards the calligraphy of the poetic couplet in Chinese, extending the relationship between words and image.

As translated by Jonathan Chaves, the Chinese-style couplet praises the bamboo for its gentlemanly virtues.

> Esteemed for its uprightness, which endures the
> frost,

And the calm void at its heart when it responds to
 the world.[6]

Taiga's calligraphy has long been admired as much as his painting. Here written in a dry-ink style, it fills the space above the bamboo with a free contrast of curved and angular strokes, themselves suggesting bamboo twigs or leaves. Every brush stroke in the work evinces the confidence and bravura of the artist which allowed him to adopt and transform the influence from Ta-p'eng. Although he produced more elaborate works such as pairs of six-panel screens, a freely painted work such as *Bamboo Endures the Frost* most fully displays Taiga's dramatic and joyous brushwork.

SA

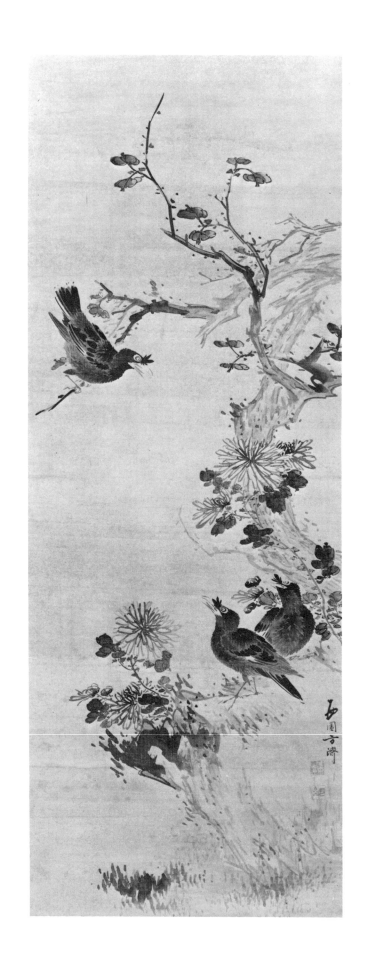

19. Fang Ch'i (J: Hō Saien, 1736–after 1793)

Autumn Magpies
Ink on silk, 97.8 × 37.5 cm.
Signature: Hsi Yuan Fang Ch'i
Seals: Fang C'hi chih in, Chu ?

The squabble of the raucous *hahachō* (magpies) can almost be heard through Fang Ch'i's depiction of their expressive postures. At least since the time of the Northern Sung dynasty master Ts'ui Po, Chinese painters have used the narrative device of communication between birds and animals to enliven their compositions. This device was popular with Shen Ch'uan (cat. 15) and his followers in Japan as well as other Chinese painters such as Fang Ch'i who found their way to the island country during the Edo period. The vertical arrangement of a jutting rock and overhanging tree branch was particularly well-suited as a backdrop for this ornithic repartee which diagonally unites the upper and lower parts of the composition across the expanse of unpainted silk.

Arriving some fifty years after Shen Ch'uan, Fang Ch'i had less influence on Japanese literati painters than the earlier master. A native of Chiang-su, Fang is reported to have visited the open city of Nagasaki several times before being cast ashore in Awa, Chiba prefecture, in 1780. Under the restrictions of Japan's seclusionist policies, he was then ordered to travel under escort to Nagasaki. Enroute he painted various views of Mount Fuji which were later published in a volume entitled *Hyōkaku kishōzu* (Paintings of the Scenic Sights in Japan Viewed by a Wandering Foreigner).[7] However, judging from the number of Fang's bird-and-flower paintings that remain, this was his favored genre.[8]

Following many of the compositional formulae of Shen Ch'uan, Fang Ch'i presents the *hahachō* in an autumn setting of chrysanthemums and nearly barren tree branches. The variety of ink tones creates a shallow but believable foreground area, while the exclusion of middle and deep distance serves to emphasize these elements. Fang Ch'i's brushwork reveals a free and bold approach to the rendering of rocks and flora. Rather than the careful build-up of texture and volume through minute strokes, Fang Ch'i preferred a wetter, more spontaneous style. The rough brushwork of the branch and rock amply conveys this spirited quality while the rapidly painted chrysanthemum leaves "colored" with dabs of ink reveal a sensibility quite removed from the conservative works of Shen Ch'uan.

MW

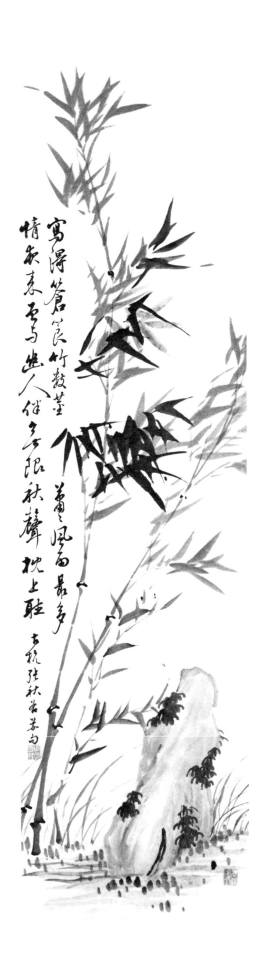

寫得蒼蒼竹數莖
情寄春雲寫與誰
人傍夕陽秋韻
瀟瀟風雨最多枕上駐
古杭張秋帆句

20. Chang K'un (J: Chō Shūkoku, circa 1744– after 1817)

Autumn Reflections
Ink and slight colors on paper, 119.6 × 33 cm.
Signature: Chang Ch'iu-ku from old Hang-chou
Seals: Liao-i pai-yu (Merely a personal pleasure),
 Kao-t'ao chu-shih (Devout layman of the
 grand surf)

Highly respected by Japanese literati, Chang Ch'iu-ku (K'un) is listed along with Fei Ch'ing-hu, I Fu-chiu, and Chiang Chia-p'u as one of the "Four Great Masters from Abroad."[9] A native of Hang-chou, Chang traveled to Nagasaki in 1781, offering the Japanese literati painters another direct source for the recent expressions of Chinese scholar painting. Because Chang's style was derived from the rich traditions of the Che-chiang area, which included such great literati artists as Wu Chen (1280–1354) and Wang Mien (1287–1359), Japanese Nanga masters eagerly sought his works and teaching.

Diary entries recording a visit to Nagasaki in 1788 by Haruki Nanko in his *Saiyū nichibo* indicate Chang's popularity among the Japanese literati. Having arrived late in the evening of the twenty-eighth day of the ninth month, Nanko's primary concern on the morning of the twenty-ninth day was to meet Chang K'un. Nanko became Chang's ardent student for several days. Nanko also records a huge banquet given in Chang's honor just before he returned to China on the sixth day of the tenth month.[10]

Works signed Chang K'un (Ch'iu-ku, "Autumn Valley") date up to the time of his departure in 1788. The reason for this abrupt cessation is not fully understood. The prevalent theory is that upon his return to China, Chang began a new phase in his painting career; he changed his name to Chang Hsin (see following entry) and produced paintings of carefully delineated flowering plants in the style of Yun Shou-p'ing (1633–1690).

Many of Chang K'un's works deal with the favored subjects of literati painters, the "four gentlemen" (bamboo, orchid, plum, and chrysanthemum). Bamboo, the "gentleman that bends in the wind but does not break," has been the most beloved of all plants to the cultured Chinese. Its strength, resiliency, stamina, and modest appearance made bamboo an ideal symbol for virtues held in high esteem by scholars. It was often used as a subject for personal artistic expression.

Autumn Reflections is one representation of Chang K'un's role as a literatus. Both the bamboo and the rock were painted freely within a simple composition, as if in immediate response to the artist's inner feelings. The tilting stalks, agitated leaves, and bending grasses echo the atmosphere described in Chang's inscription:

> While painting blue waves of bamboo,
> My feelings are stirred by heavy rains and wind.
> Summer is gone and I long for the company of old
> friends.
> Leaning on my pillow, I listen to the limitless
> sounds of autumn.

One can imagine the figure of the artist in his depiction of the solitary rock, rising up, leaning back, surrounded by the elements of autumnal weather. Even Chang's seal expresses the private nature of the work. Its translation reads "merely a personal pleasure."

Such intimate expression in painting is one of the admired traits of Chinese scholar's painting. Undoubtedly, Chang K'un's ability in this area earned the high praise given him by the nineteenth-century Japanese literati when they named him one of the "Four Great Masters from Abroad."

JW

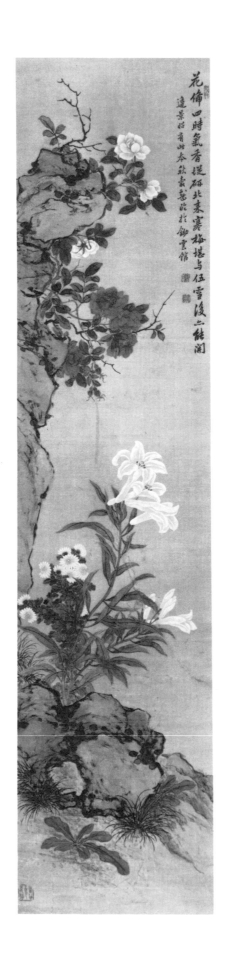

21. Chang Hsin (J: Chō Shūkoku, circa 1744– after 1817)

Lilies and Roses, 1815
Ink and colors on silk, 120 × 30.4 cm.
Signature: Playfully painted by Ch'iu-ku ("Autumn Grain")
Seals: Chang Hsin, Chang Hsin, Ch'iu-ku,
 Shang-hsin wei-liang-chih

Bird-and-flower paintings by Chang Hsin began to appear in Japan in the early nineteenth century. Yet information about Chang Hsin is scarce and controversial. Early records[11] indicate that Chang Hsin and Chang K'un (cat. 20) were the same person, Chang K'un having visited Nagasaki between 1781 and 1788. The controversy lies in the stylistic differences between Chang K'un's works, which exhibit a simpler composition and looser brushwork with very little color, and those by Chang Hsin, of which *Lilies and Roses* is a typical example. Were they truly the same artist? It is common for Chinese painters to change their names when working in a different manner, but styles usually changed from tighter and more careful brushwork in the early stages to freer expression in the later development of an artist's career. However, in the Chang Hsin/Chang K'un case, the stylistic movement would be the opposite. Chang K'un's freely brushed works are dated prior to his 1788 return to China, while Chang Hsin's more meticulous works postdate 1790.

Lilies and Roses is very similar to the corpus of Chang Hsin's works from the second decade of the nineteenth century. They all have a tall, vertical format with various blossoms growing from the ground or from rocks which rise along one side of the picture plane. The rocks are defined in ink, with modulated outline strokes and accents of wet dots which lend solidity to the forms. The flowers, on the other hand, are carefully delineated in detail; each stalk, leaf, and petal is outlined in ink and defined with bright colors. In this work, even the veins of the leaves are meticulously described. This method of freely defining rock forms and carefully describing the floral elements was commonly used among Nagasaki bird-and-flower painters of eighteenth-century Japan.

As in his other works, Chang Hsin offsets the one-sided composition with two long, vertical lines of calligraphy placed opposite the upward-reaching flowers. In this case, he begins the inscription with a verse that sets the poetic mood for his work.

 The fragrance of flowers of all seasons is released
 through my brush;
 Though the plum endures five winters, it is still able
 to blossom.

Chang Hsin concludes his inscription by writing, "At the Hall of Hoeing Clouds, 'Autumn Grain' has playfully followed a painting by Pien Ching-chao."[12] "Autumn Grain" is the courtesy name used by Chang Hsin in signing his paintings. Its Chinese reading, "Ch'iu-ku," has the same pronunciation as the courtesy name used by Chang K'un, translated as "Autumn Valley." The homophonic names further complicate the problem of the relationship between Chang Hsin and Chang K'un.

Several works by Chang Hsin refer to the "Hall of Hoeing Clouds"; some of these are dated to 1815 when Chang would have been seventy-two years old.[13] *Lilies and Roses* corresponds very closely to this group of paintings. Though there are variations in flower types and rock forms, the scrolls share a similar composition and style as well as the reference to the "Hall of Hoeing Clouds." Therefore, *Lilies and Roses* can be dated to around 1815.

A few works[14] also bear the seal found in the lower left corner which reads, "Only good and understanding friends please the heart." Japanese scholar-painters must have "understood," for works by Chang Hsin were imported in quantity. This Japanese preference for Chang Hsin's carefully detailed paintings may substantiate the postulation that Chang K'un did indeed change his style and that he did so for financial reasons.[15] In any case, Chang Hsin was a well appreciated bird-and-flower painter among Japanese collectors of the early nineteenth century.

JW

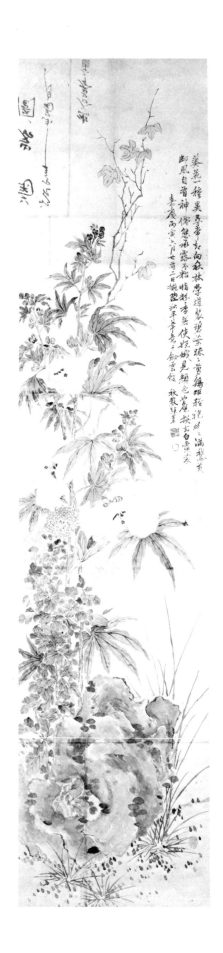

22. Noguchi Yūkoku (1827–1898)

Mallows, Chrysanthemums, and Rock, 1871
Ink and colors on paper, 133 × 31.3 cm.
Signature (on reverse): Copied by Yūkoku in the
 chrysanthemum [ninth] month of 1871
Seals: Yūkoku, Yūkoku bo

Contrary to recent Western standards, copying the works of established masters is a commonly accepted practice among Chinese and Japanese painters. Not only is it used as a means of learning brush and ink techniques, but it is also a method of recording paintings seen by the artist. When the original work is no longer extant, a copy is especially valuable. In art historical study, it provides information about the original painting as well as insights into the artistic world of the copyist. Such is the case of Noguchi Yūkoku's *Mallows, Chrysanthemums, and Rock.*

Yūkoku became famous for his own bird-and-flower paintings and probably valued Chang Hsin's work as a model. The inscription, a poem exalting the beauty of mallows, ends with Chang's signature.

> Emulating Lu Chih's[16] brush-idea, Ch'iu-ku [Autumn Grain] Chang painted this at the Hall of Hoeing Clouds on the twenty-second day of the sixth month of 1806.

Yūkoku's faithful transcription presents the earliest known dated work signed by Chang Hsin and, moreover, fills a twenty-year gap in the oeuvre attributed to Chang.[17] The copy also supports the theory that Chang K'un and Chang Hsin are one and the same man by establishing his production of works in a detailed and fully colored style as early as 1806. This is not long after Chang K'un returned to his native land from Japan (cat. 20). Thus, *Mallows, Chrysanthemums, and Rock* adds new information to the Chang K'un–Chang Hsin controversy.

Noguchi Minosuke, born into an Edo family of carpenters, demonstrated talents with the brush very early. Recognizing this ability, his parents presented him to the well-known painter Tsubaki Chinzan (cat. 23). It is recorded that Chinzan asked the boy what he wished to do. Minosuke answered, "even if I am covered with village grime, I want to paint the pure feelings evoked by the quietness found in deep mountains and misty valleys."[18] Hearing this reply, the master accepted Minosuke as a student and began calling him Yūkoku (deep and mysterious valley). The young artist soon gained a reputation for his eccentric attitudes. He never tied back his hair but kept it disheveled, on the premise that he would not cut it until he painted a "good painting." His works were highly sought, yet Yūkoku was disinterested in selling them; he preferred to live in poverty. When one of his paintings sold for the extravagant sum of 500 yen, Yūkoku thought the payment was too much; he returned half of the money and donated the other half to the needy.

Mallows, Chrysanthemums, and Rock most likely interested Yūkoku because of its subject matter. Chrysanthemums were his specialty, and his skill in rendering them displays the training he received from Chinzan. Blossoms are painted in the "boneless" manner, resulting in delicate petals which flutter against equally yielding leaves. Disregarding the meticulous delineation and muting the vibrant colors characteristic of the works by Chang Hsin, Yūkoku has imbued the composition with a lyrical softness. *Mallows, Chrysanthemums, and Rock,* although a copy, represents Yūkoku's style with free brushwork and prevalence of wash over line. Therefore, the painting not only preserves an image of the original by Chang but, at the same time, exhibits Yūkoku's personal expression.

JW

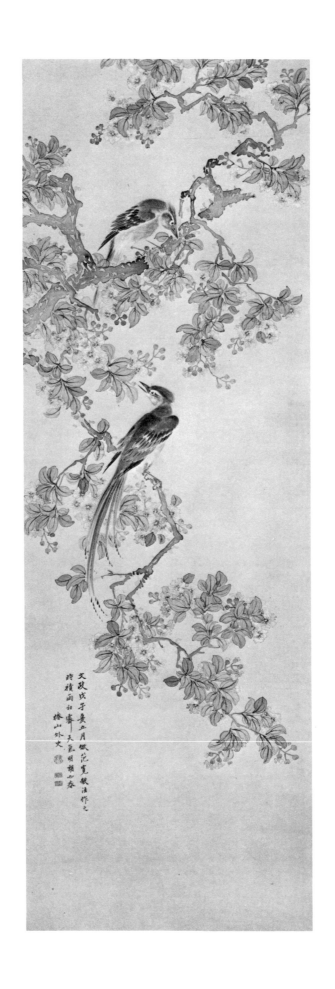

23. Tsubaki Chinzan (1801–1854)

Birds Amid Cherry Blossoms, 1828
Ink and colors on silk, 124 × 42.1 cm.
Signature: Chinzan gaishi
Seals: Chinzan, Tsubaki hitsu in
Inscription: Painted in the manner of Fan K'uan's
 brushwork in the fifth month of 1828. Clear-
 ing after a long rain is like the coming of spring.
Box inscription by Taki Katei: Written during the
 latter part of the fifth month of 1900 at Kōkō
 Studio by Katei at seventy-one.
 Seals: Katei Takiken, Shichoku

Although painted when he was only twenty-seven
years old, *Birds Amid Cherry Blossoms* reveals that
Tsubaki Chinzan was already an artist of overwhelm-
ing skill. In a compositional format favored by the Na-
gasaki school of bird-and-flower painting, Chinzan cre-
ated an empty space cell framed on two sides by
branches which radiate in an angular zigzag manner
across the painting. Upon this structure, echoed by the
poses of the birds, Chinzan has arranged the radiate
verdure of the cherry tree.

It is in the depiction of this foliage that the genius
of Chinzan is best revealed. The leaves and blossoms
have been accomplished by means of a truly "boneless"
technique wherein the pigment has been brushed onto
the silk directly without the aid of outlines. This pro-
cess imbues these forms with a quality of unfettered
weightlessness, as if they could flutter in a passing
breeze. Although extremely fine outlines are evident,
these were formed by the natural result of the pigment
as it flowed to the outer boundaries of the painted
areas at the moment before the silk fully accepted the
moisture. The crisply tensile effect suitably hints at the
turgor strength of the new leaves. The blossoms, ac-
complished in a similar manner, are even less struc-
tured than the leaves, resulting in the impression of ruf-
fled, many-petaled cherry blossoms (*yaezakura*).
Chinzan masterfully painted the branches in two tones
of ink, with the darker overlaying the lighter. Both
tones were brushed upon the surface loosely so that
empty silk or lighter brown pigment might remain in
some areas, creating the gnarled texture of bark. The
birds reveal a more careful, studied approach, with at-
tention given to specifics of the color and texture of
feathers.

Tsubaki Chinzan was the kind of magnanimous
individual from whom others may glean inspiration.
When he was seven years old his father died; Chin-
zan's destitute mother was left to raise the child as best
she could. Although specific dates are not known, it
seems that Chinzan also suffered from a tubercular
condition from early in his life. Despite this handicap
and his slight build, he was employed as an official
spear-bearer and is said to have attained a high degree
of proficiency in the martial arts. He pursued a num-
ber of musical interests including the *sho* (vertical reed
pipes) and the *koto* (13-string zither). While he enjoyed

painting as a child, he did not become a professional
artist until the low wages paid him as a spear-bearer
proved to be inadequate. He studied with Kaneko Kin-
ryō (d. 1817) and Tani Bunchō (1763–1840), but was
most influenced by Watanabe Kazan (1793–1841).
Both men deeply respected and admired each other,
and Chinzan was among those who fought to have the
death sentence commuted to house arrest when Kazan
was imprisoned for his supposedly subversive Western
studies in 1838. After Kazan's ritual suicide in 1841,
Chinzan continued to care for his master's family.

It is natural, then, that early paintings by Chin-
zan would reflect Kazan's influence. Despite Chinzan's
reference in the inscription to the brushwork of the
Northern Sung landscape painter Fan K'uan, the em-
phasis upon the accurate depiction of birds probably
stems from Kazan's interest in Western realism. The
"boneless" manner of brushwork, in all likelihood, was
also derived from Kazan, although this style was prac-
ticed by a number of artists. Nevertheless, something of
Chinzan's individual style may be discerned in this
work. The light and lyrical quality of the leaves and
flowers, while owing much to superior technique, also
stems from Chinzan's superb sense of color. In later
works, Chinzan further exploited the "boneless" man-
ner in bold, impressionistic paintings exquisitely
brushed in lush tonalities. The controlled, skillful ren-
dering of *Birds Amid Cherry Blossoms* was undoubtedly
admired by connoisseurs, as is evident from the inscrip-
tion on the painting's box written by Taki Katei (cat.
25, 26), a follower of Chinzan who acquired the paint-
ing long after the master's death.

MW

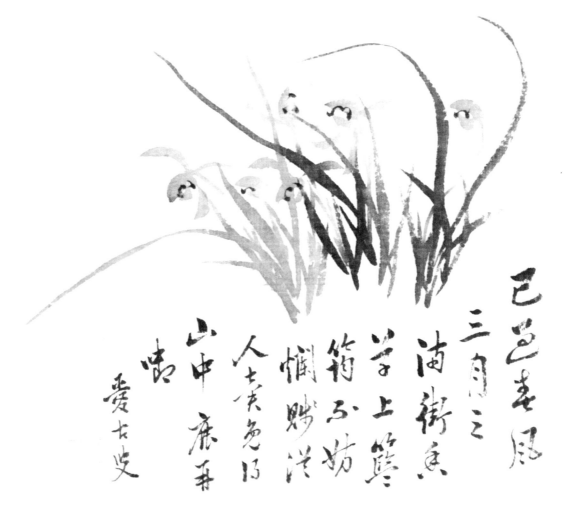

24. Ōtsuki Bankei (1801–1878)

Orchids
Hand scroll, ink on linen, 35.4 × 478 cm.
Signature: Aiko sō
Seals: Yūga, Heisō, Aiko

Bankei was the second son of the Sendai physician Ō-tsuki Gentaku, famous as a *rangaku* (Dutch studies) scholar and translator of Western anatomy books. Bankei received instruction in the Confucian classics before studying under Inoue Shimei (1730–1819) and Hayashi Jussai (1759–1832). While still in his teens Bankei traveled to Kyoto and visited Rai San'yō (cat. 49), receiving a copy of his book *Hitsuroku tateyoku—kōrai yūbo* (The Power of the Pen Proceeds in Every Direction—Good Prospects for the Future). Through his reputation as a man of letters, Bankei was appointed as an imperial tutor in 1832, and was recognized by the scholars of his clan as a gifted writer.

While holding his official position, Bankei pursued his interests in *rangaku* and Western learning, becoming particularly concerned with the study of artillery and munitions during the years of increasingly strident demands for trading concessions by Western countries. In 1841 he participated in artillery practice at Tokumaruhara, after which he composed a series of twelve poems in tribute to Napoleon Bonaparte. When rumors circulated that English warships were enroute to Japan in 1849, Bankei advocated cooperation with Russia as a means of stemming British encroachment. In 1862 he was invited to return to Sendai where he was given a military position. He served as the official archivist during the Tōhoku Campaign of 1868, but when the loyalist forces were defeated in their attempts to resist Western demands, Bankei was imprisoned for his involvement in the incident. Although he was released after a short time, he considered himself to be "the surviving retainer of a ruined country."[19]

Given Bankei's feelings of dissatisfaction after the peaceful "opening" of the country, it is not surprising that he chose the epidendrum orchid as the subject of this hand scroll. Since the time of Ch'u Yuan (332–268 B.C.) in China, the orchid has symbolized the purity and uncompromising moral fortitude of scholars.[20] During the Yuan dynasty (1271–1368), the unassuming nature of the plant became even more closely associated with the lives of literary gentlemen. These intellectuals managed to flourish despite their self-imposed withdrawal from a government dominated by the foreign Mongol court.

Orchid painting in Japan began in the Muromachi period (1333–1568), when Zen priests who trav-eled to the continent in search of religious instruction returned to Japan with paintings of orchids. Japanese monks thereupon produced their own renditions of these paintings. After generations of neglect, the orchid was once again adopted as a painting subject by Obaku monks and pioneers of the scholar painting tradition in Edo period Japan. While these artists were undoubtedly aware of the symbolic significance of the orchid in China, it was adopted into their repertoire as part of the more general "four gentlemen" category of painting which also included bamboo, blossoming plum, and chrysanthemum.

More than his Japanese forebears, Bankei must have felt some affinity to the discontented intellectuals of the Yuan dynasty when Japan was forced to open her ports to foreign ships and to submit to unequal trade agreements. The unpolished quality of his brushwork in the *Orchids* hand scroll suggests a truly unstudied approach to painting. The leaves, while brushed in thick, confident strokes, are simply conceived without complicated widening and narrowing of the lines to suggest the twisting of the blades in space. Variations in ink tonalities have also been kept to a minimum. As a result, the flowers become part of a pattern of dancing strokes accented by the dark dots of their stamens, rather than carefully rendered individual blossoms. The meaty strength of the leaves and the buoyancy of the flowers reveal something of Bankei's outspoken character. The poetry which is interspersed between the various orchid compositions, however, is lyrically aloof. The opening stanza centers on the sensory enjoyment of the plant itself, without overt mention of its historic significance:

> The winds of spring have already blown,
> The streets are filled with the fragrance of orchids
> from bamboo baskets.
> Why don't we sell them to people for a trifle,
> Instead of letting the mountain deer feed upon
> them?

MW

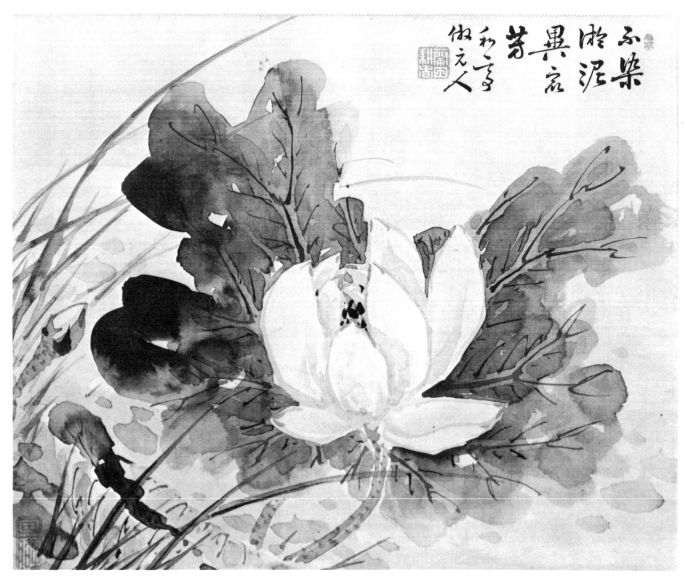

25. Taki Katei (1830–1901)

Lotus in Bloom
Ink on satin, 25.6 × 31.5 cm.
Signature: Katei emulating the Yuan
Seals: Katei, Randen Kōkō, Gaheki

Petal after petal, the flawless lotus blossoms, delicately distinguished by subtle variations of ink wash, rise above their murky source to permeate the atmosphere with an ethereal essence. The immediacy of this moment is effected by the skillful application of blurring strokes and dimming ink tones. Masterly suffusion of wet ink over the surface creates living forms with little obvious traces of brushwork. Delicate ink harmonies between the blossoms and the pervading misty vapors distill the quiet, yet penetrating essence of nature.

This visual expression consonantly responds to the imagery evoked in the inscription:

> Untainted by muddy waters,
> The most fragrant of flowers

The lotus "is a symbol of purity and perfection because it grows out of mud but is not defiled, just as Buddha was born into the world but lived above the world; and because its fruits are said to be ripe when the flower blooms, just as the truth preached by Buddha bears immediately the fruit of enlightenment."[21]

This exquisite and emotional depiction of the lotus blossoms fully exhibits the virtuosity of its creator, Taki Katei. Although Katei is more known for his later works, accomplished in a refined manner with iridescent colors,[22] his mastery of the "boneless" technique to produce forms in ink wash alone was certainly one of the reasons for his artistic fame in the latter half of the nineteenth century.

Katei's skillful handling of ink wash is a direct reflection of his respect for Tsubaki Chinzan's (cat. 23) mature works, which were noted for the masterful use of the "boneless" painting method. Indeed, Katei belongs to the artistic lineage of Chinzan through Araki Kankai (1789–1860), who was Chinzan's student and one of Katei's teachers. Taki Katei's esteem for Chinzan may also be reflected in his later stylistic move to a more super-realistic manner; Chinzan demonstrated technical finesse in meticulously executed bird-and-flower paintings in the early stages of his career.

In addition to Chinzan's influence, Katei's artistic training included instruction from the Nanga masters Ōoka Umpō (1765–1848) and Tetsuō Somon (cat. 31, 32) with whom Katei studied while in Nagasaki around 1850. Like many other Japanese literati painters, Katei also learned from Chinese scholar-painters living in Nagasaki such as Ch'en I-chou (cat. 35) and Hua K'un-t'ien.[23]

After the Meiji Restoration in 1868, many Japanese artists and scholars promoted a reform movement towards westernization in painting. Katei, involved in a peripheral role, remained true to his Nanga heritage. Works such as *Lotus in Bloom* not only display his debt to technical training in the Nanga manner, but also his allegiance to literati ideals of emotional expression. His signature, "Katei emulating the Yuan," is a direct reference to Yuan dynasty literati masters. This loyalty is surely what earned Taki Katei a place as one of the most influential masters of the "old school" during the early years of the Meiji period.

JW

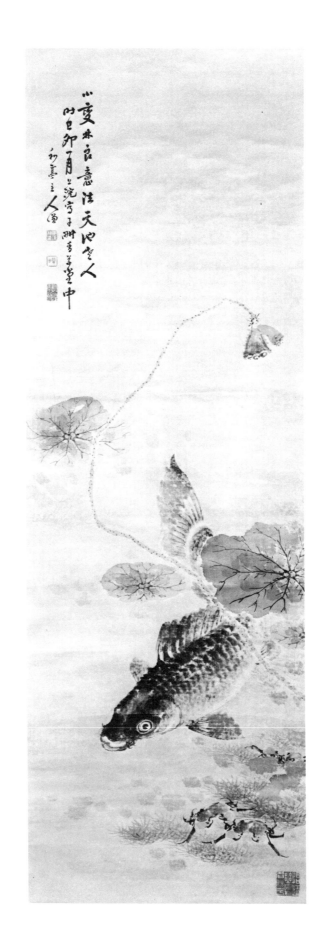

26. Taki Katei (1830–1901)

Shimmering Carp, 1879
Ink and color on satin, 148.1 × 50.1 cm.
Signature: Painted by Katei Shūjin
Seals: Shinkenka-in, Randen, Kōkōkanshū, Ijō yū-
 chō meika

Light, refracted through clear water, suddenly shim-
mers upon an armor of scales. The warrior, although
aware of his momentary exposure, remains undisturbed
as he determinedly continues on his way. Thus, the
lone carp freely and steadfastly angles through the
pond, oblivious of the crabs below.

Taki Katei's precise brushwork brilliantly cap-
tures the vibrant will of the carp and the sharp clarity
of an instant in time. The artist uses to his advantage
the often problematic tendency of satin to absorb ink
wash. Katei masterfully layers ink tones in subtle gra-
dations to transform glistening grey hues into fish
scales and soft pastels into lotus plants. Complemen-
tary colors reinforce a superb design; the graceful curve
of the carp flows into the bending stem of the withered
lotus plant, completing a smooth S-shape movement.

Although Katei was a major figure in art circles
of the Meiji period, he "told people that he felt out of
tune with the times and that he should not be consid-
ered a 'Meiji' artist."[24] During the early years of the
restoration, the trend towards Western styles grew
stronger with the promotion of the Japanese Art Coop-
erative Society. At that time, Katei traveled throughout
the country and remained unaffiliated with any partic-
ular ideology. He maintained a personal style by pro-
ducing conservative works based upon his training in
the literati manner (see previous entry). This Nanga
heritage and his independent attitude were fully recog-
nized by Katei's contemporaries. As his fame grew, he
participated in numerous national and international
exhibitions, including the Vienna Exposition of 1872
and the Chicago World Exhibition in 1892. In 1894,
Katei was appointed a member of the art committee of
the imperial household.

Symbolizing Katei's perseverance against the artis-
tic tide, *Shimmering Carp* poignantly reflects the artist's
sentiment. The inscription supports this personal
expression:

> A slight variation of Lin Liang, but following the
> master Hsu Wei;
> Painted at the Hall of Hoeing Fragrant Grasses in
> the first month of 1879.

The reference is not only to Hsu Wei's (1521–1593)
"boneless" brushwork but also to Hsu's unorthodox at-
titude, for the Ming literatus worked in an eccentric
mode, "caring little for fashion."[25] His mad handling
of the brush and ink countered the exacting strokes
produced by most of his contemporaries. Lin Liang
(active 1488–1505) probably provided the inspiration
for the subject; he is known for his lifelike images in
the bird-and-flower tradition.

Just as in Katei's *Lotus in Bloom, Shimmering
Carp* is a vivid testimony to the artist's deep respect for
his Chinese forerunners. The painting speaks for itself,
fulfilling the suggestion made in the artist's seal,
"Please your hearts with exquisite flowers and birds."

JW

Notes

1. These seals are slight variants of those on a 1741 screen as published in Contag and Wang, *Seals of Chinese Painters and Collectors,* 179.

2. "Boneless" usually means without outlines, although in the case of Shen Ch'uan it generally refers to using hidden outlines.

3. For examples of works by Shiseki and Kakutei, see Cal French, *Through Closed Doors.*

4. For further information, see Stephen Addiss, *Obaku: Zen Calligraphy and Painting.*

5. Stephen Addiss, *Obaku: Zen Calligraphy and Painting,* catalogue #36.

6. Here Taiga is referring to the hollow in the middle of the bamboo culm.

7. See Tsuruta Takeyoshi, "Hō Sai hitsu fugakuzu to hyōkaku kishōzu."

8. Eight bird and flower paintings by Fang Ch'i are published in Suzuki Kei's *Comprehensive Illustrated Catalogue of Chinese Painting.* Fang's painting of Mount Fuji in the Hashimoto collection is also reproduced.

9. Asano Baidō (1816–1880) names these four artists in his *Sōhōkaku shoga meishin roku.* However, he may have misunderstood Fei Ch'ing-hu for Fei Han-yuan. See Tsuruta Takeyoshi, "Hi Kangen to Hi Seiko."

10. Toda Teisuke, "Chōshin to Chōkon."

11. The earliest record is that of *Mo-lin chin hua,* 1871, edited by Chiang Pao-ling, 5, 15b–16a.

12. Pien Ching-chao, also known as Pien Wen-chin (ca. 1356–1428+), a native of Sha-hsien in Fu-chien, was noted for his colorful bird-and-flower paintings.

13. The Kanzaki family auction catalogue of 1925 lists a Chang Hsin painting which is signed with a reference to the *Hall of Hoeing Clouds* and dated to the twentieth year of Chia-ch'ing (1815). See Toda, "Chinese Painters in Japan": 28. Several panels in a pair of six-fold screens in the Nagasaki Prefectural Museum have the same reference, are dated to 1816, and give Chang's age as seventy-three. See Howard Rogers, "Beyond Deep Waters," 34, and Tsuyoshi Baba, "Chō Shūkoku to Chō Shūkoku," 8.

14. See Toda Teisuke, "Chōshin to Chōkon," *Kokka* 891 (June, 1966): 28, plate 7, and Toda Teisuke and Ogawa Hiromitsu, eds., *Chugoku no kachōga to Nihon,* volume 10 of *Kachōga no sekai* (Tokyo: Gakken Co., 1983), plates 121, 127, 129, and 132.

15. Toda Teisuke puts forth this theory and thoroughly discusses the Chang Hsin/Chang K'un question in "Chōshin to Chōkon," 24–34. Supporting Toda's argument that Chang Hsin and Chang K'un are one and the same person are Howard Rogers, "Beyond Deep Waters," 28–35, and Baba Tsuyoshi, *Nagasaki o otozuretta,* 68–70.

16. Lu Chih (1496–1576), a friend of Wen Cheng-ming, was a poet who painted landscapes and bird-and-flower paintings while living in a mountain retreat.

17. Howard Rogers, "Beyond Deep Waters," 31.

18. This and the following biographical material can be found in *Meiji hyakunen bijutsukan,* 6.

19. This and other biographical data have been taken from Maeda Ai, "Ōtsuki Bankei," *Nihon koten bungaku daijiten* (Tokyo: Iwanami Shoten, 1983–85), 444.

20. While Ch'u Yuan was falsely accused and banished to the northern hinterlands, he remained the humble servant of the king of Ch'u.

21. Anesaki Masaharu, *Buddhist Art in its Relation to Buddhist Ideals with Special Reference to Buddhism in Japan* (Boston: Museum of Fine Arts, 1915), 15–16.

22. Katei's best known work in this style is his *Peacock,* dated 1892, in the Tokyo National Museum. It is reproduced in Koike Masahiro, ed., *Dento to kindai soshoku—Meiji-Taishō-Shōwa no kachō,* vol. 9 of *Kachōga no sekai* (Tokyo: Gakken Co., 1982), pl. 7.

23. Very little is known about this artist, except that he is supposed to have arrived in Japan in 1842 according to *Koga biko,* vol. 49, 2190.

24. Charles H. Mitchell, *Biobibliography of Nanga, Maruyama, Shijo Illustrated Books,* 87.

25. James Cahill, *Parting at the Shore,* 159.

Part Three: The Influence of Chiang Chia-p'u

While I Fu-chiu and Shen Ch'uan were the most influential visiting artists of the early eighteenth century, Chiang Chia-p'u (1744–after 1839) was the most important of the artists who came to Nagasaki in the first years of the nineteenth century. He presented a more sophisticated version of Chinese orthodox literati painting than the Japanese had known before, and his conservative technique had an influential effect upon Nanga masters who wished to increase their expertise in what they considered the "true" Chinese tradition. Chiang himself painted in several different styles. His more elaborate landscape compositions on silk were built up of many small brush strokes, creating a formal structure that was enlivened by colorful details. Chiang also painted in a more simplified style, usually with ink on paper, that had some of the sparse elegance of the works of I Fu-chiu. Finally, Chiang also did both bird-and-flower compositions and calligraphic scrolls, testifying to his range as an artist.

Chiang Chia-p'u's greatest influence was upon the literati painters of Nagasaki, the most noted of which were Hidaka Tetsuō (1791–1871), Kinoshita Itsuun (1799–1866) and Miura Gomon (1809–1860). Called the "Three Great Literati Painters of Nagasaki," these artists mastered the Ch'ing dynasty conservative tradition that Chiang represented. Their style was additive in approach, building up landscape compositions gradually by overlaying brush strokes and wash to create relatively full compositions. While this technique lacked the dramatic appeal of much early Nanga brushwork, it did provide a satisfying sense of texture and fullness within which the individual touch of each artist could be appreciated.

Chiang Chia-p'u's influence was not limited to Nagasaki. His conservative style gradually spread through Japan via his paintings and his own and his pupils' teachings. Among the artists who followed his model was the calligrapher and scholar-artist Nukina Kaioku (1778–1863), who became the center of the literati circle in Kyoto during his latter decades. Another artist who was strongly influenced by Chiang was Sugai Baikan (1784–1844), a painter from Sendai who renounced the ecelectic Nanga style he had learned in Edo in favor of more orthodox Chinese techniques. Baikan had considerable success as a painter in Kyoto after returning from Nagasaki, but ended his career back in Sendai as an artist for the Date clan.

One may debate the ultimate importance of Chiang Chia-p'u in Japan. While on one hand he did teach and influence a number of Nanga masters, on the other hand the trend towards a more conservative literati style had already begun before his first visit to Nagasaki. Like all artistic influences, the time had to be ripe for the orthodox Chinese tradition to succeed in Japan; Chiang did not effect the change on his own, but rather encouraged it by his example. That his artistic influence remained in Japan is proven by a copy of one of Chiang's landscapes made in the Meiji period by a Shijō school painter, Nishiyama Kan'ei (1833–1897). Ultimately Chiang Chia-p'u came to be known as one of the "Four Great Masters from Abroad."

SA

甲子春日玉崎山銀兄艾山水秀美
另有一種佳趣作此以供一笑
中华 桥圃

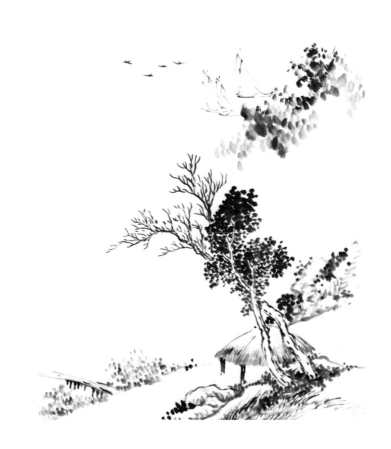

27. Chiang Chia-p'u (J: Kō Kaho, 1744–after 1839)

An Enjoyable Scene in Nagasaki, 1804
Ink on paper, 118 × 47.5 cm.
Signature: Chung-hua Chia-p'u
Seals: Chiang Ta-lai in, Chia-p'u

Chiang Chia-p'u, who came from Su-chou in Chiang-su,[1] made his first visit to Nagasaki in 1804. His brush style was based upon the orthodox literati school of the early Ch'ing dynasty. As a literati artist, Chiang painted landscapes in the manner of the "Four Wangs" as they had interpreted the famous masters of the past, such as Mi Fei, K'o Chiu-ssu, Kao K'o-kung, Ni Tsan, Huang Kung-wang, Wu Chen, Wang Meng, and Shen Chou. He also painted ink-play subjects of the literati: the orchid, bamboo, and pine. His influence on scholar painting in Japan during the late Tokugawa period can be seen in his instruction of three of the great scholar-painters of Nagasaki, Hidaka Tetsuō (cat. 31, 32), Kinoshita Itsuun (cat. 33), and Miura Gomon (1809–1860). Japanese artists by this time thoroughly accepted the idea of Chinese literati painting as a legitimate form of scholarly pursuit.

This landscape, executed in the first year of Chiang's visit to Nagasaki, is after the style of Ni Tsan. The work includes many of Ni's famous motifs—rocks, sparse trees, a lonely pavilion, and large areas of blank space representing water. Yet, from Chiang's inscription, we are told that the artist had more in mind than the standard Ni Tsan composition:

> In the winter of 1804, I went to Nagasaki. Viewing the scenery there, I found another kind of pleasure. I painted it and you can just take it as a joke.

Chiang's buoyancy is expressed in the painting by the contrast of the tranquil atmosphere of the foreground and the rhythmical movement of the middleground.

The focus of the painting is on the foreground and middleground. Chiang painted the empty pavilion using contrasting brush strokes, with the straw roof accomplished in light, soft strokes while the supporting columns were brushed in stiff, darker strokes. Similarly, the branches of the trees, painted in dry strokes, contrast with the dabs and wet dots of the foliage. The direction of these dotting strokes leads the viewer's attention to another standard motif, the board bridge.

The bushes along the bank of the river in the middleground are simplified into quickly done dabs. The tonal variation of these strokes creates a vibration that is further reflected in the three boats and birds in flight. The rhythmical movement starts from the bushes on the right and proceeds through the sailing boats, thus balancing the V-shaped design created by the birds.

Chiang Chia-p'u painted more elaborate landscapes in color upon occasion, displaying his mastery of technique. In this painting, however, he tried to pursue the idealistic Chinese theme of the mind landscape, using standardized motifs in his composition. Even though this painting supposedly represents an actual scene in Nagasaki, it is still, in spirit, a completely Chinese scene.

CW

清言如晉人亹亹

濁酒以澆書不了了

乙丑仲書

橋園江文來

28. Chiang Chia-p'u (J: Kō Kaho, 1744–after 1839)

Calligraphy Couplet, 1805
Ink on paper, 91 × 27.5 cm.
Signature: Chia-p'u, Chiang Ta-lai
Seals: Chiang Ta-lai in, Chia-p'u[2]

Part of Chiang Chia-p'u's importance in the history of Japanese art lies in his transmission of Chinese literati ideals to Japanese Nanga artists. This is evident in the *Tetsuō garon,* a treatise written by Chiang's most gifted pupil, Hidaka Tetsuō (cat. 31, 32), wherein he indicated that an upright personality, calm mood, and profound knowledge were essential for scholarly painting. It is clear from such writings that the Japanese scholar-painters not only followed the artistic styles of those artists who visited Japan, but also adopted their philosophical ideas.

Chiang Chia-p'u distinguished himself as a scholar; he may have been awarded the official title of *tz'u-shih*[3] which appears with his signature on some paintings.[4] Although his career as a government official in China seemed promising, Chiang returned to his home town to care for his ailing father, an act of filial piety high on the list of Confucian virtues. From that time onward, he devoted himself to scholarly pursuits.

In addition to painting in the literati style, as seen in the previous landscape, Chiang also brushed calligraphy. In this couplet, Chiang has expressed his literati values in a highly moralistic tone:

> The pure comments of the Chin people are acceptable,
> [But] the tainted quality of the *Han shu* is reproachable.

Chiang indicates his refined character by admiring the Chin people's philosophical discourses, while disdaining the *Han shu* as a medium of deception.[5]

The couplet, in a forceful running script, was written by tilting the brush to the side, thus using the flexibility of its tip to create a thicker line. The first dot of most of the characters was done with a heavily loaded brush. However, the connections between the strokes were done quickly and sharply. In addition to creating the effect of "flying white" where the paper shows through the brush strokes, some of the rapid turning strokes also enclose almond-shaped spaces.

In this calligraphy, the meaning of the couplet and the strength of Chiang's brush style express this upright personality, literati taste, and scholarly background. These are the virtuous qualities most admired by Japanese as well as Chinese intellectuals, and helped make Chiang one of the "Four Great Masters from Abroad."

CW

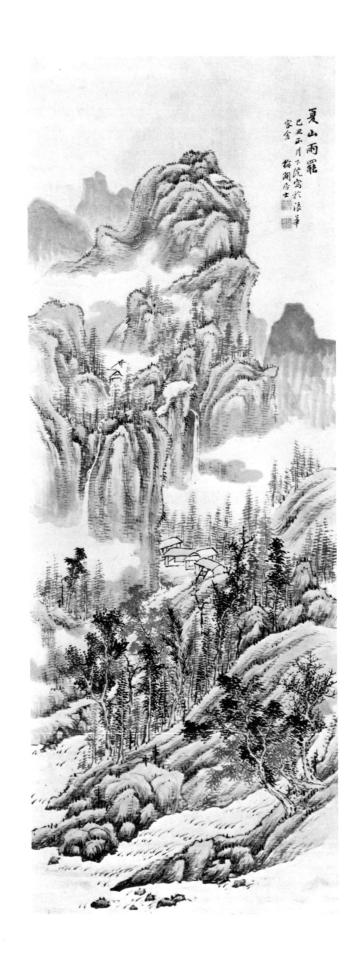

29. Sugai Baikan (1784–1844)

Summer Mountains in Clearing Rain, 1829
Ink and light colors on paper, 129.4 × 47.8 cm.
Seals: Sugai Gakuho, Sen ? Tōsai, Tōka yoka
 (Reading and writing at leisure)

High above a mountain village a wine shop's welcoming flag flutters in the breeze. A summer shower has just abated and the misty clouds which skirt the rocky cliffs have begun to dissipate. The inhabitants of the tiny village have yet to return to their tasks, remaining secluded within the protective cover of their huts. The valley shimmers in pinks and greens, seemingly freshened by the cooling rain. Only the muffled voice of the river breaks the silence as it sweeps away the impurities of this distant place.

While many of Sugai Baikan's early paintings follow the broad, sometimes rough style of Tani Bunchō (1763–1840), *Summer Mountains in Clearing Rain* more closely resembles the elaborate landscapes of Chiang Chia-p'u.[6] The proficient use of small, horizontal accent strokes to enliven the surface of the rocks and the long dry strokes to describe their corporality are elements of the Chinese master's style. Additionally, the careful attention given to details such as the interesting variety of trees and countless rock shapes can also be found in the works of Chiang Chia-p'u. However, while Chiang's more formal style tends to be excessively complicated, at times overtly displaying his technical skill, Baikan produced less elaborate works of greater restraint. In *Summer Mountains* he captured the transient passing of a rain shower without obscuring the lyrical mood with an overly complex composition.

Summer Mountains in Clearing Rain reflects something of the austere personality of Baikan. A native of Sendai, he was first introduced to the tradition of scholar painting by Nemoto Jōnan (dates unknown) who is said to have expounded the virtues of the great men of the Yuan dynasty. After moving to Edo, Baikan studied with the versatile painter Tani Bunchō, the leading proponent of the Nanga tradition in the east. However, because Baikan disagreed with his teacher's eclectic approach to art—Bunchō practiced the styles of all major schools of painting in Japan—Baikan traveled first to the Kansai area and then to Nagasaki in search of a teacher of greater literati purity.

Baikan lived in Nagasaki for more than ten years during which time he became a friend and follower of the Chinese merchant-painter Chiang Chia-p'u. Before Chiang returned to China he requested a painting of plum blossoms from Baikan. The aspiring Japanese artist was so touched by Chiang's recognition that he is said to have chosen the Chinese ideographs for Baikan, meaning "plum gate" for his sobriquet in memory of the occasion.[7]

After leaving Nagasaki, Baikan lived for a time in Kyoto where he enjoyed a degree of popularity within the artistic and literary circle of Rai San'yō (cat. 49). Upon the request of a lord of the Date clan who particularly admired his paintings, Baikan returned to Sendai. Although he received a stipend of rice for his services, he reportedly died in poverty at the age of sixty. Having preferred the life of a solitary wanderer, Baikan never married; he claimed that his paintings were his children.[8]

MW

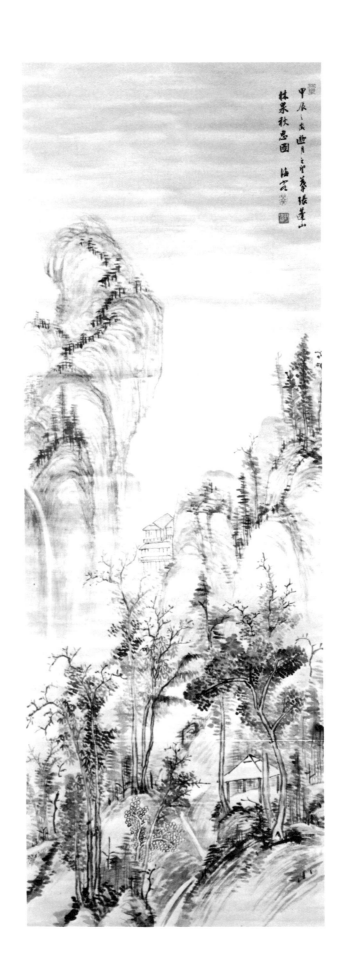

30. Nukina Kaioku (1778–1863)

Autumn Thoughts on a Garden Landscape, 1844
Ink and light color on satin, 141.6 × 50.6 cm.
Signature: Kaikyaku
Seals: Rinraku, Sōshū, Shōsho

Nukina Kaioku's exemplary dedication and refinement as a scholar made him the central figure among *bunjin* in Kyoto after the death of Rai San'yō (cat. 49) in 1832. As the second son of the Yoshi family of samurai in Tokushima province on Shikoku, Kaioku's frail physical demeanor and scholarly inclinations made it inevitable that he should abandon his position as a warrior. Since his mother was from a family of Kano school artists, he first received instruction in that style of painting. However, in keeping with his father's rank and status, he was soon being schooled in Confucian philosophy and the Chinese classics. His aptitude and appetite for Chinese studies developed rapidly. At seventeen he visited an uncle who lived in the vast monastery complex of Mt. Kōya where Kaioku was able to examine and copy the calligraphic works of the founder of Japanese Shingon Buddhism, Kōbō Daishi (774–835). Rather than returning to Shikoku, Kaioku traveled widely, eventually becoming a pupil of the Osaka scholar Nakai Chikuzan (1730–1804). For a short time Kaioku taught Confucianism in Osaka, but when he was thirty-four he settled permanently in Kyoto. His eminence among the Kyoto-Osaka literary elite continued to grow, and by 1828 he had gained such a reputation as a literatus that he was able to open a Confucian school.[9]

While Kaioku is ultimately more famous for his calligraphy, he also produced a large number of notable landscape paintings. As with the works of his contemporaries Rai San'yō and Uragami Shunkin (1779–1846), Kaioku's paintings reveal a studied, conservative approach to the Chinese-derived landscape tradition. This orthodoxy was the result of increasing numbers of continental paintings in Japan. To a certain extent, it was also a reaction against the undisciplined exuberance of earlier masters such as Ike Taiga (cat. 7, 18).

Although Kaioku undoubtedly viewed many paintings in private collections in Kyoto, he also came into contact with more works during his travels. In Nagasaki he studied Chinese brush techniques with Hidaka Tetsuō (cat. 31, 32) who had been a pupil of the visiting Chinese painter Chiang Chia-p'u (cat. 27, 28). In *Autumn Thoughts on a Garden Landscape* Kaioku followed the more complex style of Chiang, whose style ultimately derived from the Four Wangs of the early Ch'ing dynasty (see Part One, note 1). In his

inscription Kaioku mentions Chiang P'eng-shan as the source of his inspiration. While Chiang Chia-p'u's sobriquet was Lien-shan, P'eng-shan is not recorded among his names.[10] Kaioku's reference may simply be an error or it may reveal yet another artistic name for Chiang Chia-p'u.

The stability of the mountain forms, the roughly outlined tree trunks and the indistinct underbrush of horizontal strokes is reminiscent of Chiang. However, Chiang's elaborate interplay of light, texturing strokes and dark accent dotting produced attractive surface patterns in a formal style. Kaioku's composition is more spontaneous. The variety of tree forms and foliage, while creating a dense thicket in the foreground, is not patternized. Similarly, the tree motifs atop the tallest mountain create an irregular zigzag back into space. Even the mountain forms which rise in repeated ovoid shapes are less regularly arranged than in works by Chiang. As a result, *Autumn Thoughts* lacks the immediate visual appeal of works by the Chinese master, yet Kaioku's style recaptures the subtle austerity of true scholar painting.

MW

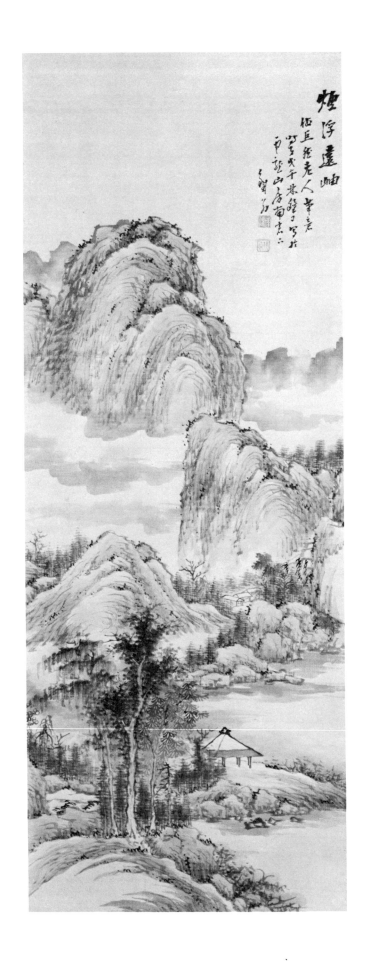

31. Hidaka Tetsuō (1791–1871)

Floating Mist on Distant Peaks, 1858
Ink on silk, 123.5 × 47 cm.
Signature: Tetsuō
Seals: Shaku Somon, Tetsuō
Inscription: "Following the brush idea of 'old
 man' Chu-jan, painted at the Cloud Dragon
 Pavilion under the south window, in the sixth
 month of 1858."[11]

Hidaka Tetsuō was born in Nagasaki, the son of a dyer. His father died when he was ten years old, and he then entered Shuntokuji, a Rinzai Zen temple in Nagasaki. He took the monastic name Somon, and eventually became fourteenth abbot of the temple. Interested in painting from his early years, he first trained under Ishizaki Yūshi (1768–1846), a Nagasaki scholar-artist, and then with Chiang Chia-p'u (cat. 27, 28). At the end of the Tokugawa era, many aspiring *bunjin* who came to Nagasaki visited Shuntokuji. One of these visitors was the Chinese merchant-artist Ch'en I-chou (cat. 35). It is said that after Tetsuō received Ch'en's guidance, his painting became even better. With Kinoshita Itsuun and Miura Gomon, Tetsuō is considered one of the "Three Great Literati Painters of Nagasaki."[12] Although also a landscapist, Tetsuō specialized in orchids, and he is said to have received his orchid-painting method in a dream. He took his name Tetsuō from the two men he most admired, the orchid painter Tesshū Tokusai (died 1366), and his Zen master Ken-ō (dates unknown).

 Tetsuō was one of several Nanga artists active in Nagasaki in the early to mid-nineteenth century. Under the influence of a new influx of Chinese artists, they painted in a style closer to Chinese models, more conservative than the art of their predecessors. *Floating Mist on Distant Peaks* is evidence of this new conservatism and greater first-hand knowledge of Chinese brushwork. Similar to that of many traditional Chinese landscapes, the composition is clearly divided into foreground, middleground, and background. The foreground promontory is topped by trees and an empty pavilion. The organization of these elements, without human figures, resembles the painting of the Yuan dynasty master Ni Tsan. From the foreground, mountains recede in a zigzag manner, rising upward to the high distance. Mist, suggested by wash and empty silk, separates the major land formations; the monumental peaks cut off any view into deep space. As in later Chinese painting, the landscape elements are all rendered close to the picture surface. A certain familiarity with ancient Chinese masterpieces is evident in the similarity of Tetsuō's rounded mountains with those of the Five Dynasties period master Chu-jan, after whom the painting is inscribed.

 Although Chu-jan's famed alum lumps are lacking, the brushwork is faithful to his spirit and, by extension, to the literati ideal. The most striking element of brushwork consists of the dragon-vein *ts'un* (internal strokes in rock and mountain forms), laid down in several layers and patterns to indicate land textures. The hooked *ts'un,* characteristic of Tetsuō's style, heighten the three-dimensionality of the rocks. The wavelike outlines of the mountains enliven the line, which modulates and exhibits a range of tonal gradations. Dots, varying in size and sometimes connected in series, add to the vitality of the landscape. The variety of brushwork in a composition without human figures expresses the sentience of nature and the solitude of human existence.

JC

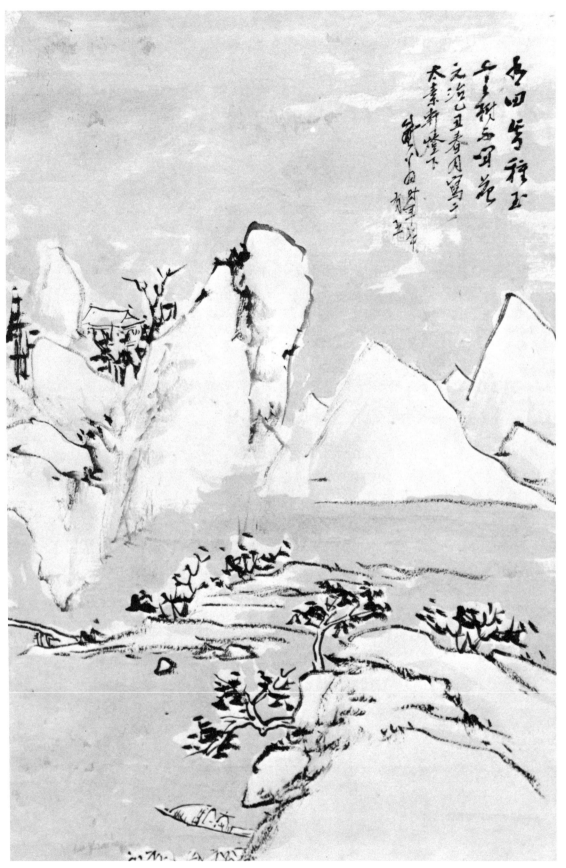

32. Hidaka Tetsuō (1791–1871)

Snowscape, 1865
Ink on gold-flecked paper, 47.6 × 31.4 cm.
Signature: Tetsuō, age 75
Seals: Somon, Tetsuō
Inscription: "Painted in spring of 1865 at Tai-so
 retreat, under the lamplight."

A lone scholar in a boat fishes on a wintry stream; there is no one else to share his thoughts. His hook and line forgotten, he looks out on the landscape, contemplating the desolate hills. A few houses perched atop the hills and nestled in the valleys are the only other traces of human existence.

This painting of a lone scholar-fisherman continues a long Chinese literati tradition of the portrayal of such subjects which evoke feelings of disengagement from worldly affairs, remoteness, and loneliness. Both the subject and the tripartite composition—foreground promontory with trees, an expanse of water, a farther shore with mountains beyond—reflect literati traditions dating from the Yuan dynasty.

The clarity of the composition perhaps mirrors the scholar's thoughts as he drifts upon the water. Yet the brushwork, extremely abbreviated and agitated, not only reveals the freedom of a sketch, but may also betray feelings of conflict and alienation on the part of Tetsuō; this kind of restless brushwork also appears in other winter landscapes by the artist. The stark hills are covered with snow, indicated by the white paper which contrasts with a tonally varied grey wash representing water and sky and the luminosity of a winter evening. A dry brush has been dragged across the surface in three or four tonal gradations in some areas, often combined in a single stroke. Bare outlines with some areas of dry brush which stray onto the land forms have been substituted for the extensive use of texture strokes evident in *Floating Mist on Distant Peaks* (cat. 31).

This free, untrammeled brushwork, typical of Tetsuō's snowscapes, reflects the significance of the subject as a vehicle for the artist's political and philosophical views. The ten-character couplet, written in a running-cursive script which is similar to the brushwork in the scroll, illuminates the meaning of the work:

> One in vain cultivates jade at Lan-t'ien;[13]
> Golden trees do not blossom.

The import of these lines is related to the political situation at the close of the Tokugawa period, of which the artist was deeply aware. In the middle decades of the nineteenth century, the power of the *bakufu* government was rapidly declining, and many intellectuals took action in favor of the restoration of power to the emperor. There is evidence that the prominent scholar and advocate of these revolutionary ideas, Yanagawa Seigan (1789–1858), knew Tetsuō. In 1855, Seigan inscribed the box of *Clearing Mists Reveal the Green Hills*[14] by Ch'en I-chou, a painting which Tetsuō cherished and inscribed in the same year. Whether Tetsuō was involved in Seigan's activities is unknown. Tetsuō's opinions, however, are reflected in an anecdote that he refused a samurai's request to study painting with him by advising the unemployed warrior that the time was at hand to throw down the brush and take up the sword.[15] In this context, the inscription can be interpreted to indicate Tetsuō's frustration with his and other intellectuals' inability to change the contemporary social and political situation, and the rigid nature of Tokugawa rule.

Tetsuō painted until the end of his life, when he withdrew to his retreat to spend time in contemplation and reading sutras, refusing all visitors. He valued the hermit's life which allowed him to meditate in solitude, with brush and ink stone as his only companions.

JC

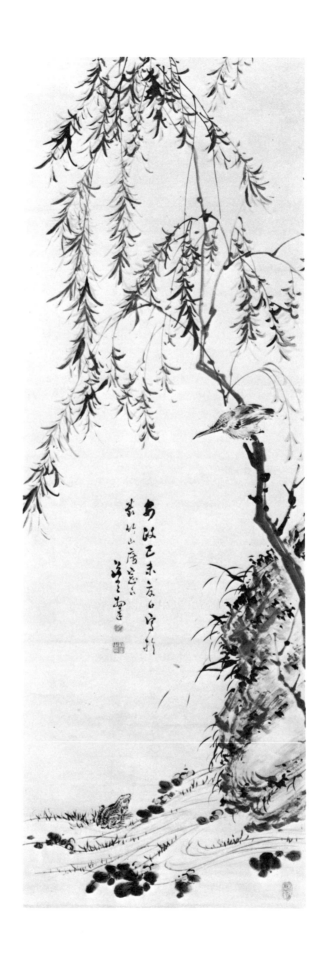

33. Kinoshita Itsuun (1799–1866)

Kingfisher and Frog, 1859
Ink and light colors on paper, 132 × 45.7 cm.
Signature: Yōchiku Sanbō sōgai
Seals: Itsuun, Shōsai no in, Bonshin shinbutsu
 shugi

"How did you jump so high?" the frog seems to ask as he sits nearly hidden among the pebbles and grasses. The kingfisher to whom the question is addressed casually perches on a willow branch high above. He gazes outward, completely absorbed in thought, and ignores his amphibian co-star below. This hypothetical scenario, however, nearly goes unnoticed against its eye-catching backdrop.

A supple young willow gracefully bends to let its newly blossomed greenery wave in a slight breeze. Each leaf is a single, lightly brushed stroke of ink. These strokes subtly vary in tonality from a deep, metallic grey to an almost imperceptible tint of blue. The delicate execution of the painted leaves contrasts with the rapid application of dark, wet ink which forms the outlines of the pebbles on the ground below. The paper has absorbed the ink, resulting in blurred edges which then lend a vaporous atmosphere to the scene. Avoiding the visually banal, short dry brush strokes appear where they are unexpected; the frog's back looks textured rather than slick, and the soft feathers of the kingfisher are belied by scratchy strokes of orange coloring. This virtuoso production featuring pastel hues, wet and dry brushwork, and charming creatures is the creation of the nineteenth-century Nanga artist, Kinoshita Itsuun.

Itsuun was a Nagasaki artist who spent most of his life in the port city. Foreign contact, then, was not a novelty, and its influence on his painting is quite evident. Itsuun learned bird-and-flower painting in the style of Shen Ch'uan (cat. 15) from Ishizaki Yūshi (1768–1846). However, the majority of Itsuun's work in this genre abandons their carefully detained and highly colored manner. Instead, it reflects the more lyrical and "boneless" style of bird-and-flower painting by Chiang Chia-p'u (cat. 27, 28). *Kingfisher and Frog* owes much to the loosely brushed works of Chiang, imitating his "boneless" technique and simplicity of forms. Traces of Shen's influence still remain in Itsuun's composition; the bending willow creates a space cell in which the artist has signed and dated the work.

In 1865 Itsuun made the long journey to Edo. There, he visited his friend Tōdō Ryōun (1809–1886) who asked Itsuun why he had chosen "jora" (like a sea shell) as a sobriquet. Itsuun's reply reveals the contemplative nature of his character; he did not create paintings for the fickle tastes of the day. Like the sounds which eternally echo in empty sea shells long after their original inhabitants have gone, his artistic creations were meant to withstand the prevailing trends of later generations. In 1866 Itsuun boarded a ship returning to Nagasaki. He never reached home; a sudden storm wrecked the vessel, and Itsuun was lost at sea. He had chosen an appropriate cognomen; over a century later, works like *Kingfisher and Frog* are still admired as timeless creations by Kinoshita Itsuun, one of the "Three Great Literati Painters of Nagasaki."

JW

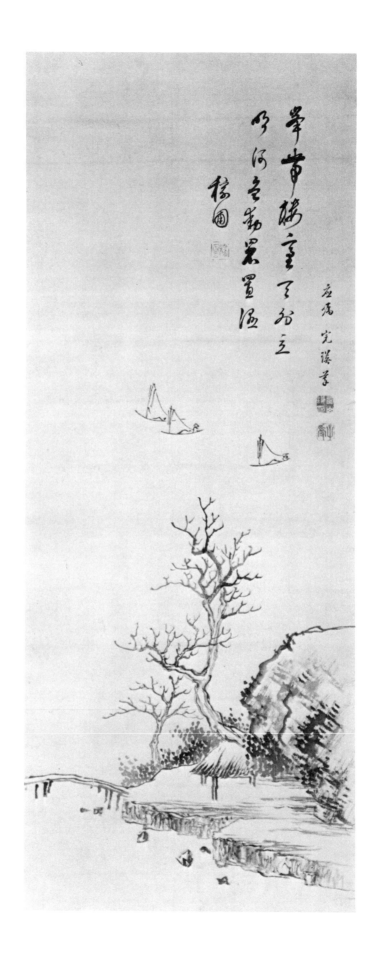

34. Nishiyama Kan'ei (1833–1897)

Morning Landscape, after Chiang Chia-p'u
Ink on paper, 83.7 × 33.6 cm.
Signature: Painted by Kan'ei to comply with a
 request
Seals: Chia-p'u (painted), Nishiyama-ken in, Jushi

Nishiyama Kan'ei was trained in the Shijō manner of painting by his father, Nishiyama Hōen (1801–1867). Like Hōen, Kan'ei utilized carefully graded washes together with minute line work to produce relatively realistic landscapes and lyrical paintings of birds and flowers. This style of painting originated with the creative genius of Matsumura Goshun (1752–1811), who began to work in this manner after having achieved recognition as a Nanga painter under his teacher Yosa Buson (1716–1783). It is possible, therefore, to trace Kan'ei's artistic lineage back to Buson in light of the fact that Kan'ei's father was a pupil of Matsumura Keibun (1779–1843), Goshun's pupil and younger brother. This artistic link to Buson may explain, in part, Kan'ei's interest in the Nanga tradition as reflected in his *Morning Landscape.*

Kan'ei's training in Confucianism might also have led him to experiment with continental modes of expression. During his youth he studied the classics with Gotō Shoin (1797–1864) and after achieving a reputation for his literary talents, Kan'ei came to serve the lord of Akashi as a Confucian scholar. In copying a work by the merchant-painter Chiang Chia-p'u, Kan'ei was careful to include the Chinese master's poem. Thus, *Morning Landscape* reflects Kan'ei's interest in both the artistic and literary aspects of the scholar painting tradition:

> Surrounded by mountains, the towers rise beneath
> the firmament;
> The Milky Way has fled the sky and dampness cov-
> ers the morning.

In Kan'ei's copy, little of the evocative landscape style of Buson and Goshun is present. Their lush vegetation and often bucolic human elements have been replaced by barren trees and an unpeopled land spit. The sparse composition—tall foreground trees and low, empty pavilion—recalls the river landscapes of the Yuan dynasty master Ni Tsan. However, while Ni may be the distant creator of this type of landscape, the close vantage point, the addition of boats and the reduction of compositional elements suggest generations of creative variation on the theme by later Chinese painters. In rendering such a painting, Chiang Chia-p'u was affirming his debt to the masters of the past. Thus it is natural that Kan'ei, in attempting to fashion his life on the moral code of Chinese scholar-gentlemen, should have chosen this time-honored theme for one of his forays into Chinese-style painting.

MW

Notes

1. Chiang Chia-p'u is a painter who has not been discussed in Chinese art historical books or art criticism. The information about Chiang's personal history derived from Japanese sources is also limited. He is said to be from Hang-chou *fu*, Lin-an prefecture in Che-chiang province. However, he sometimes signed his name Su-tai Chiang Chia-p'u (see the bamboo scroll in the Kumita collection). Su-tai, or Su-chou in Chiang-su province has been a major artistic center since the Yuan dynasty, and was honored as a cradle of Chinese literati culture. It is a habit of Chinese painters to indicate their hometown in front of their name. Thus Chiang Chia-p'u probably came from Su-chou in Chiang-su province, instead of Hang-chou in Che-chiang province.

2. Although this calligraphy dates to just one year after the previous landscape, it bears variant versions of similar seals.

3. *Tz-u-shih* is an official position first established in the Han dynasty, but after the Yuan and Ming dynasties the title was no longer used. Therefore whether Chiang really occupied an official position in the Ch'ing government is still questionable.

4. In his most famous work, a hand scroll entitled *T'ien-tai-shan chen-ching*, he signed himself "Chung-hua-chou *tz'u-shih* Chiang Ta-lai."

5. The first line of this couplet has obvious meaning, while the second is unusual and somewhat obscure. "Chin people" indicates those intellectuals of the Chin dynasty (265–420 A.D.), especially Tung Chin (317–420 A.D.), who liked to make statements which were mainly influenced by Taoist naturalism. The *Han shu* is the official history of the Former Han dynasty compiled by P'an Ku and others in the first century A.D. It is not common to describe a book as having a morally tainted quality, particularly the *Han shu*, one of the official dynastic histories.

6. See Toda Teisuke, "Chinese Painters in Japan," 163 for an example of a more elaborate landscape.

7. Iizuka, Beiame, "Nanshūga gaisetsu," *Nihonga taisei*, vol. 10 (Tokyo, Tōhō Shoin, 1933), 21.

8. Kono Motoaki, *Nihon no nanga*, vol. 1 of *Suiboku bijutsu taikei bekkan* (Tokyo: Kodansha International, 1976), 165.

9. Matsushita Hidemaru, "Bunjin—sono tenkei," *Rai San'yō*, vol. 18 of *Bunjinga suihen*, 122–123.

10. "Chiang P'eng-shan" is also unknown as a separate painter.

11. The phrase "under the south window," found in several inscriptions by Tetsuō, may refer to a poem by T'ao Yuan-ming (T'ao Ch'ien, 365/372–427), the famed Eastern Chin period recluse. In the poem entitled "The Homecoming," T'ao leans against the sill of the south window of his retreat, assuaging his frustration at his inability to influence the political situation of the time.

12. For more information on Tetsuō, see Nagami Tokutarō, *Nagasaki no bijutsushi*, 1974.

13. An area in Shensi province known for its rich lodes of jade.

14. Published in Tsuruta Takeyoshi, "Chin Isshū to Chin Shiitsu," 38.

15. Published in Tsuruta Takeyoshi, "Chin Isshū to Chin Shiitsu," 38.

Part Four: Chinese Visitors and Japanese Copies

Although none of the later visiting Chinese painters was to become as influential as I Fu-chiu, Shen Ch'uan, or Chiang Chia-p'u, several artists journeyed to Japan during the later Edo and Meiji periods who painted in the literati style. Ch'en I-chou (ca. 1800– after 1850), like many of his predecessors, was a merchant; he made the voyage to Nagasaki a number of times in the second quarter of the nineteenth century. His conservative style and command of orthodox brushwork provided models that especially encouraged the Nanga masters of Nagasaki in their pursuit of the Chinese literati ideal.

It was during this period that the number of actual Chinese paintings in Japan increased to the point where native artists had a wide range of literati styles from which to learn. Chinese paintings were copied more frequently, especially by the conservative Nanga masters in Kyoto. Okada Hankō (1782–1846) and Yamamoto Baiitsu (1783–1856) were two leading painters of their generation who often copied Chinese works, not only in their youth but also in their maturity. Not all the paintings they copied were masterpieces, or even works by famous artists of the continent. Although the Japanese were by now well aware of the major Chinese painters, they took an interest in lesser-known artists as well, and furthermore were not bound by Chinese aesthetic judgements. Hankō, for example, copied a work by the little-known Tung Hsiao-ch'u, perhaps because of its curious patternization of landscape elements. Known as a connoisseur of Chinese painting, Baiitsu copied a large painting by Lan Ying, who was certainly a well-known artist but who was not always considered part of the literati tradition in his homeland. By being quite free in their choice of models, Japanese artists were able to infuse Nanga with a broader range of styles than were accepted during the same era in China.

With the opening of Japan in the Meiji period (1868–1912) Chinese visitors were at last able to travel freely in the island nation, visiting such artistic centers as Kyoto, Osaka, and Nagoya. Hu T'ieh-mei (1848–1899) was a merchant-artist who became known for his high degree of skill in brushwork, thorough knowledge of earlier and contemporary styles, and wide variety of subject matter. The large corpus of his surviving works in Japan testifies to the appreciation he received as well as to his mastery of the literati painting tradition.

Wang Yin (circa 1829–after 1892) represents the fusion of scholar-artist and professional in nineteenth-century China. Like almost all of the visiting painters he was more celebrated in Japan than in his homeland, but he was by no means inferior to other conservative artists of his day in either technique or in literati spirit. While his works are not as common as those by Hu T'ieh-mei, they evince a poetic sensibility that is especially notable in his impressions of the Japanese landscape. The paintings of Hu and Wang demonstrate that the later visitors to Japan may have been less influential than their forebears, but they possessed at least equal if not greater talent.

SA

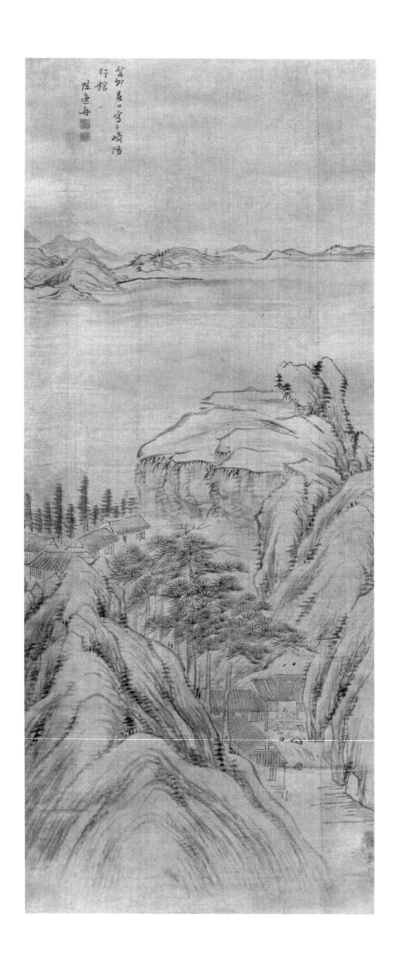

35. Ch'en I-chou (J: Chin Isshū, circa 1800–after 1850)

Contemplation Among Pines, 1843
Ink on silk, 57.9 × 77.5 cm.
Signature: Ch'en I-chou
Seals: I-chou, Yuan-hsi, ?

To expand his business, the prosperous merchant Ch'en I-chou traveled to Japan many times during the years 1823–1850.[1] His dates are unrecorded, but he was probably born not much later than 1800 if we assume that he was in his later twenties when he first sailed to Nagasaki in 1827.

Although Ch'en was a merchant, he obviously had already become familiar with various styles of Ming and Ch'ing painting in his native region, Che-chiang province. He took his studio name from a place called Ying-wu chou in P'ing-hu county, Che-chiang. Some recorded inscriptions indicate that he may have lived for a time in Chiang-su province. He undoubtedly traveled extensively in the southeastern coastal area of China in order to expand his trade.

The quality of the poetry written on some of his works indicates that the extent of Ch'en's education was limited. However, he was familiar with a diverse range of artistic traditions. He is said to have followed Wang Hui (1632–1717) and Wang Yuan-ch'i (1642–1715) in landscape, and the Yang-chou school in the "four gentlemen" and bird-and-flower subjects. Ch'en was also interested in Tung Ch'i-ch'ang (1555–1636), painted at least one Mi-style landscape, and probably copied one or more landscapes by the Ming dynasty master T'ang Yin (1470–1523).

While in Nagasaki, Ch'en associated with Chinese and Japanese artistic and literary figures, such as Chiang Chia-p'u (cat. 27, 28) and Hidaka Tetsuō (cat. 31, 32). They were part of a loose circle of scholar-artists who often gathered to drink, paint, and compose poetry.

As is typical of most of these eighteenth- and nineteenth-century Chinese visitors, Ch'en was unrecorded as an artist in China (there are no known paintings surviving on the mainland), but was quite respected and influential among literati painters in Japan. This influence is most clear in his role as one of the artists who transmitted the orthodox literati style of late Ming and early Ch'ing artists to Japan.

This standard literati style is evident in *Contemplation Among Pines.* The subject, a figure sitting in a pavilion in the mountains, is a central theme which was elaborated from the Yuan period on; here the artist follows early conventions. The figure is situated in a pavilion overlooking a grotto in the foreground; the composition is completed by a body of water in the middleground and a line of mountains in the far distance. In this elaboration of the structure of landscapes by Ni Tsan (1301–1374), the emphasis is placed on foreground motifs which fill nearly half of the picture surface. The brushwork is bland and repetitive, the forms built up of many individual strokes. The inscription indicates only that the painting was done in 1843 at Nagasaki Inn.[2] *Contemplation Among Pines* represents Ch'en's later style and reflects his close adherence to the orthodox literati mode. Ch'en's personal adaptation of this literati style consists in his rather unusual arrangement of standard elements. The somewhat awkward and patternized brushwork in this scroll, however, is not typical of his finest work.

JC

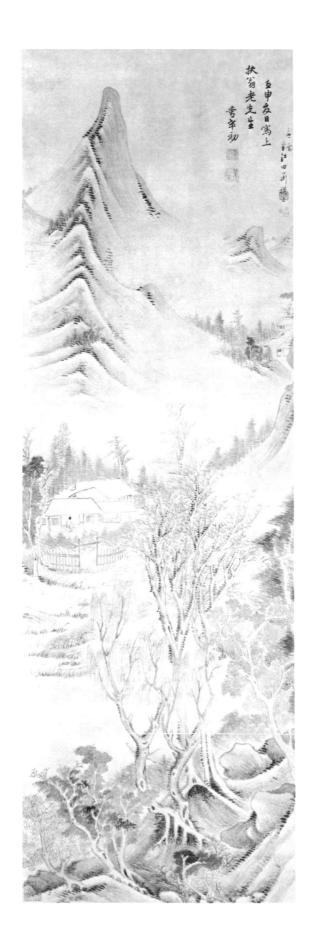

36. Okada Hankō (1782–1846)

Autumn Landscape, after Tung Hsiao-ch'u
Ink and light colors on silk, 141.1 × 47.2 cm.
Signature: Copied by Hankō Okada
Seals: Hankō, Shiushi, Kogomemushi, Tung
 Hsiao-ch'u yin (painted), Tung Jen-ch'ang
 shih (painted)

As the son of the rice merchant and artist Beisanjin (1744–1820), Okada Hankō was raised in an atmosphere of prosperity and scholarly pursuits. Influenced by his father's Sinological interests, he also became part of the literati circle in Osaka. Hankō inherited his father's position as a Confucian scholar serving Lord Tōdō of the Tsu fief (present-day Mie prefecture), but he retired in 1822 to devote himself to artistic pursuits.[3] From his retreat by the Yodo River near Osaka, he developed close contacts with the literati elite of Kyoto including the poet, painter, and calligrapher, Rai San'yō (cat. 49).

While Hankō's early paintings exhibit a marked debt to his father's powerful and eccentric style, his later works became increasingly conservative and faithful to the Chinese models he sought to emulate. In this respect, Hankō was part of a general trend away from the unbridled expressions of individualistic masters such as Beisanjin and Uragami Gyokudō (1745–1820). Perhaps due to the accumulation of greater numbers of Chinese works in Japan, Japanese scholar-artists such as Hankō began to perfect the subtleties of their brush techniques and compositional arrangements. Hankō, Nakabayashi Chikutō (1776–1853), Nukina Kaioku (cat. 30), and Uragami Shunkin (1779–1846) created benign works of quiet refinement.

Hankō's favorite continental model was the time honored Mi style of landscape painting, which featured layered horizontal dots to create soft land masses and moist atmospheric effects. *Autumn Landscape,* however, is evidence of Hankō's interest in other methods of painting. In this work, he copied a composition by Tung Hsiao-ch'u, a little known artist of the Ming dynasty (1368–1644) whose remaining oeuvre reflects the tradition of Tung Yuan. In Hankō's copy, however, much of his personal style is evident in the use of Mi dots and the long, fiberlike texture strokes derived from his father. Given the paucity of information concerning Tung Hsiao-ch'u, it is difficult to discern the exact elements of the Chinese artist's style from Hankō's copy. However, in the careful attention to detail evident in the splitting of the tree branches into a multitude of twigs, the minute delineation of leaves and the layering of the mountain peaks, Hankō used elements not found in his other works. In this respect, *Autumn Landscape* reveals the breadth of artistic exposure and experimentation taking place among late eighteenth- and early nineteenth-century scholar-painters.

MW

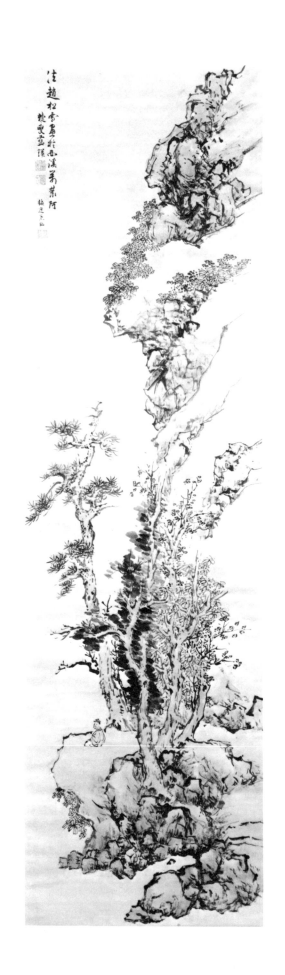

37. Yamamoto Baiitsu (1783–1856)

Autumn Contentment, after Lan Ying
Ink and light colors on satin, 176.7 × 51.5 cm.
Signature: Copied by Baiitsu Ryō
Seals: Lan Ying chih yin (painted), T'ien-shu fu
 (painted), Baiitsu rōjin, Rinbon

Among the Chinese artists most revered during the second half of the eighteenth century in Japan was the Hang-chou painter Lan Ying (1585–ca. 1665). Works by this eclectic, late Ming dynasty painter were not only sought after but also copied numerous times. Nanga painters in particular were attracted to Lan Ying's interpretations of the respected masters from the Sung and Yuan dynasties.[4] Noro Kaiseki (cat. 8) and Kuwayama Gyokushū (1746–1799) incorporated certain of Lan's stylistic aspects, while other painters copied his works directly. Among the latter were Tani Bunchō (1763–1840), Nakabayashi Chikutō (1776–1853), and Yamamoto Baiitsu.[5]

In *Autumn Contentment,* Baiitsu has copied one of Lan Ying's favorite compositions.[6] Bulging mountain forms rise up one side while the foreground is dominated by huge trees grasping onto several smaller boulders. Jutting from between the majestic trees is a horizontal plateau upon which sits a solitary scholar. In his various versions of the composition, Lan Ying sometimes incorporated two scholars in conversation, or distant hills offsetting the vertical mountain wall.

In Baiitsu's copy, the broken outlines are built up by brush strokes which progressively darken in tone. Volume is indicated by subtle shades of wash. The color tonalities are complementary; the light blues of two trees visually balance the sepia tones highlighting the other trees and the scholar's robe. Each tree is a distinct variety, the most noticeable being the pine which, rising above the others and silhouetted against blank satin, points to the inscription.

> Following the methods of Chao Meng-fu (Sung-hsueh) painted at the Hall of a Myriad Leaves on West Lake.
>
> > Old Butterfly Lan Ying

By including this transcription, Baiitsu has completed his copy of an autumn landscape by Lan Ying now in the Nakano Matazaemon collection.[7] Both works are on satin and are approximately the same size. However this painting does exhibit Baiitsu's personal touch. The careful layering of strokes creates faceted edges unlike the hard outlines of the original. Even though Baiitsu put more emphasis on horizontals and verticals, his wider range of wet and dry brushwork and greater variety of dark and light ink tones soften the effect of the entire scene. In this manner, Yamamoto Baiitsu is an important transmitter and synthesizer of later Chinese paintings like *Autumn Contentment* by Lan Ying.

JW

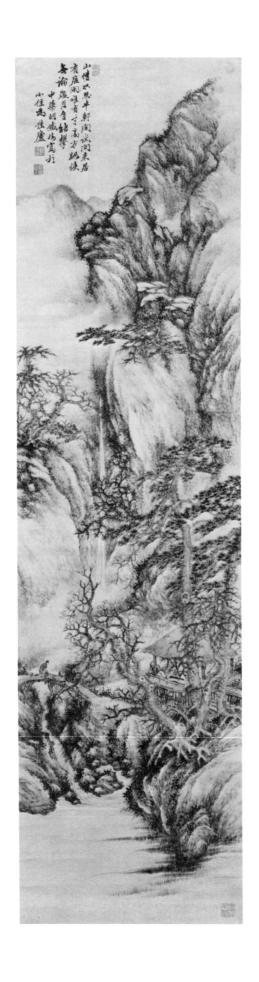

山情於思平鄭鄙試閑來居
有庭閑時有事高方躋陟
無論歲月自鈆攀
中藥明做伤寫於
小住馬佳廬

38. Hu T'ieh-mei (J: Ko Tetsubai, 1848–1899)

Mountain Hermitage Landscape
Ink and colors on silk, 130.6 × 35.4 cm.
Signature: Hu T'ieh-mei
Seals: An-ting (stability), Hu T'ieh-mei, Yao
Ch'eng-tzu

Like so many of the Chinese who visited Japan in con-
nection with the trading ships, little is known of the
merchant-artist Hu T'ieh-mei. Records indicate that he
came to Japan in 1879 and that in the summer of the
following year he took up residence in Nagoya. Due to
the Meiji Restoration and subsequent opening of Ja-
pan to foreigners, Hu was able to travel widely in Ja-
pan over the next six or seven years. There is evidence
that he visited Kyoto, Osaka, and Niigata prefecture;
on these journeys, he was entertained by Japanese in-
tellectuals and patrons of the arts who admired his
works.[8] Perhaps it was during such a sojourn that Hu
painted this landscape. The inscription in Chinese-style
verse reflects the spirit of his travels:

> Lingering in a small pavilion with thoughts of
> mountains and streams—
> To dwell in such a place one must have idle hours
> And with a lofty spirit attain solitude
> Without noting the passage of time.

This poetic image is perfectly reflected in the
painting in which a scholar leisurely enjoys a waterfall
from his thatched hut. Hu has carefully included var-
ious details within the pavilion that suggest the pas-
times of a sage, such as books and a *ch'in* (Chinese
zither). An attendant is making his way to the hut
bearing a kettle of fresh water for tea.

The landscape forms rise toward the top of the
scroll, dwarfing the tiny pavilion. One immediately
senses the grandeur and overpowering strength of na-
ture, in which man is but a small detail. In the ortho-
dox manner of Ch'ing dynasty landscape painting, Hu
has brought the landscape elements to the surface by
effectively sealing off gaps in the mountain that might
have suggested deep space. Great attention has been
lavished on the build-up of the rocks, trees, and foliage.
Dry, scumbled brushwork has been carefully layered to
define the rough surface of the rocks. These in turn
were overlaid with areas of wet accent dots. Similarly,
the tall trees which partially obscure the pavilion have
been meticulously elaborated with large branches that
divide successively into minute twigs. Despite this great
build-up of surface texture, Hu has masterfully accom-
plished a clear depiction of nature which shimmers
with a myriad brush strokes.

MW

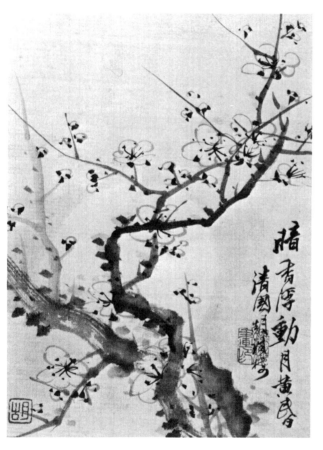

暗香浮動月黃昏
清國
胡鐵梅寫

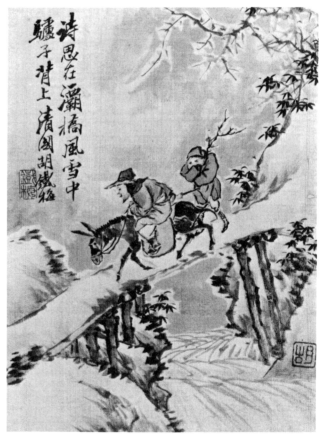

詩思在灞橋風雪中
驢子背上 清國胡鐵梅

39. Hu T'ieh-mei (J: Ko Tetsubai, 1848–1899)

Literati Album, dated 1885 on one leaf
Ink and color on satin, 26.5 × 19.6 cm.
Signature: Hu T'ieh-mei
Seals: T'ieh-mei, T'ieh-mei hua yin, Hu

While this album is similar in poetic spirit to *Mountain Hermitage,* here Hu T'ieh-mei used a smaller, more intimate format to brush a variety of subjects in a less formal manner. The album contains ten compositions, including landscapes, bird-and-flower subjects, and a figure painting; most of these works bear a short inscription. In the first leaf, Hu depicted a winter scene in which a sage and his attendant are crossing a bridge. The two-line verse furthers the mood of the scene while immediately revealing Hu's scholarly tendencies:

> Atop a donkey's back
> amid the wind and snow—
> Poetic thoughts of mine
> at Pa Bridge.⁹

In this scene, the scholar seems to be prodding his donkey with a stick while his attendant follows, clutching a small branch of plum blossoms. Hu has accomplished this vignette by means of the same dry, scumbled brushwork that is evident in *Mountain Hermitage,* but here without the addition of the wetter washes and brushwork to denote texture and foliage. Instead, larger areas of satin are left unpainted in order to give the effect of snow. In addition, grey wash has been brushed in for the background; this further imbues the landscape with the heavy cloudiness of a winter's day. Hu limited his palette to mostly cool colors which he sparingly used for the blue and green jackets of the scholar and attendant, and in some light dabs for the bamboo which had not been covered by snow.

The next leaf of a flowering plum branch contrasts with the preceding landscape in conception, but beautifully mirrors its poetic intent. In this case, the subject of the scholar's inspiration, only hinted at in the first leaf by the small branch carried by the attendant, has become the focus of the painting. The blossoming plum tree was one of the famous "four gentlemen" subjects of painting, together with bamboo, chrysanthemum, and orchid. During the Yuan dynasty (1279–1368), literati painters chose the plum to represent scholarly enlightenment despite the intellectual deprivation they felt under the Mongol government. Just as they managed to endure foreign domination, the plum is able to send forth blossoms even in the cold desolation of winter. In this work, Hu rapidly painted the rough texture of the branch by using a dry brush.

The blossoms were also quickly rendered but with lighter, more fluid strokes that hint at their delicacy. The entire composition has been set against a luminous moon which was lightly delineated behind the plum by faint washes of blue. Rather than directly coupling the plum with the preceding composition, or overtly explaining its symbolic value, the poetic inscription avoids the obvious:

> The delicate fragrance drifts
> Through the moonlight evening.

Also included in this album are lighter, sometimes humorous depictions, such as a painting of the Chinese god of longevity (Shou-hsing) with two of his attributes, the fungus of immortality (*ling-chih*) and a gourd (*hu-lu*). Hu painted the Taoist deity leaning against a rock where he has stopped to rest, and included a short inscription that is in keeping with the great elder's state of tranquility: "Hold your spirit with peacefulness." While the entire painting exhibits Hu's characteristically dry, agitated line, the robes and facial features were accomplished by means of a more careful, finer brushwork. Light blue pigment was loosely added to the robes while flesh tones in a chiaroscuro-like manner were used for the immortal's visage.

From these works, it is possible to understand something of the breadth of Hu's ability. He was not only capable as a landscape painter, but was equally skilled in bird-and-flower and figure studies. Additionally, through Hu's inscriptions which sometimes refer to ancient poetry, one is able to glean something of his ability as a scholar.

From the date, equivalent to 1885, written on one of the final leaves of this album, it is logical to assume that this work was painted while Hu was still in Japan. However, the inscription on the painting of the Taoist immortal mentions that the work was produced while passing through Yu-chou. It is conceivable, though, that Hu traveled to Yu-chou only in his imagination, and so intended this statement figuratively. The preface inscription signed "Shu-yuan I-shih" (Hu's studio name) is dated to the sixth month of 1886 and so may have been added just before Hu's actual return to China.

MW

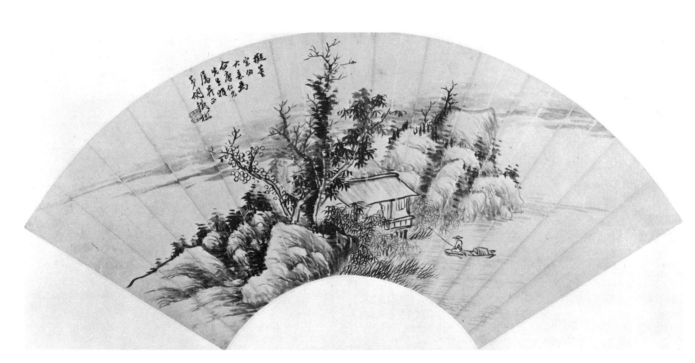

40. Hu T'ieh-mei (J: Ko Tetsubai, 1848–1899)

Quietly Passing Time in Boat and Pavilion
Ink on paper with traces of mica, 19 × 53.5 cm.
Signature: Hu T'ieh-mei
Seal: Hu Chang

As the water laps at reeds and rocks, a scholar and a fisherman exchange friendly greetings and pass the time in polite conversation. The gentleman's hut juts over the water on wooden pilings, partially obscured by a thicket of trees and bamboo. Surrounded by the gentle currents of the river, the rocky peninsula provides an ideal retreat whose solitude is broken only by the occasional visitor who casts his lines into the shadow of the pavilion.

Although Hu T'ieh-mei states in the inscription that he followed the style of Tung Tsung-po (Tung C'hi-ch'ang, 1555–1636), nothing of Tung's formalistic manipulation of compositional elements is present. The rocks rise from the water as organic masses. As in *Mountain Hermitage* these shapes are given a sense of mass and weight by Hu's application of a series of short, wet texture strokes. Only in the somewhat schematic application of the horizontal Mi dots can one discover a reference to the Tung Ch'i-ch'ang. The manner in which Hu has clustered these strokes, particularly about the central trunk of the main tree, relates to the style of the late Ming dynasty theorist. However, in general conception, *Quietly Passing Time in Boat and Pavilion* reveals Hu's persistent use of stable compositional arrangements and orthodox brush modes.

After returning to China in 1886, Hu settled in Shanghai and opened a shop which catered to the Japanese population of the area. It is likely that Hu produced paintings to sell in his shop to his Japanese admirers. He also began publishing the *Su-pao* newspaper, eventually becoming involved with the Wu-hsu pien-fa movement in which the young emperor Kung Hsu attempted to enact political reforms against the wishes of the powerful dowager empress. When the uprising was defeated in 1888, Hu sought political asylum in Japan, probably arriving in late autumn of that year. Unfortunately, illness seems to have overtaken the artist after this voyage to Japan, accounting for a lack of paintings which date to this period.[10] For this reason, it is likely that *Quietly Passing Time* was painted prior to Hu's unsuccessful political involvement. The casual life of a wanderer that Hu had enjoyed on his earlier visit to Japan was never repeated; he died in Kobe less than one year after his last journey.

MW

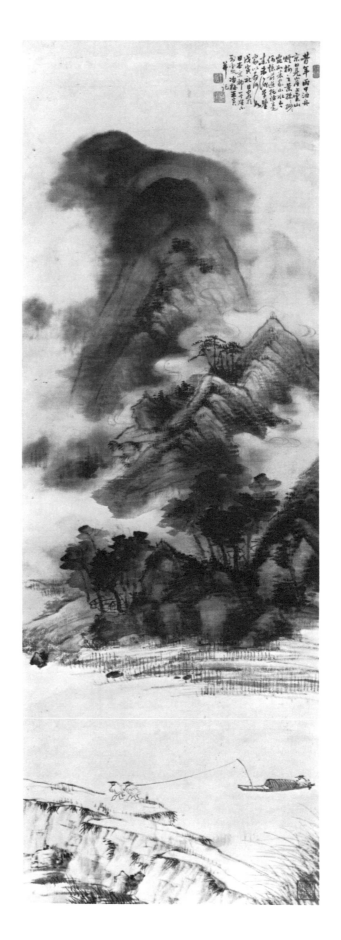

41. Wang Yin (J: O Ya-bai, circa 1829–after 1892)[11]

Misty Landscape, 1878
Ink on silk, 138.6 × 49.9 cm.
Signature: Painted and inscribed by Yeh-mei
 Wang Yin in the lodging of "I-ch'en pu-tau
 ch'u" (A place without the intrusion of even a
 bit of dirt) in Kyoto, Japan, 1878
Seals: Shui-t'ien i-se (River and sky merge in one
 color), Wang Yin, Yeh-mei, Hsu-pai sheng-
 shih chi-hsiang sui(The shapeless white emerges
 in a room, the symbol of a propitious year)

Born in Ching-ling (Nan-ching), the young Wang Yin moved with his family to Shanghai to escape the Boxer Rebellion. He later became a professional painter and worked in the eclectic literati manner established by the early Ch'ing masters. He journeyed to Japan in 1877, 1878, and 1879 as one of the few visiting Chinese painters during the early Meiji period.[12] As a versatile artist, Wang Yin showed his talent in various styles of brushwork. On most of his paintings he wrote either inscriptions or poems. He followed the traditional scholar-artist school despite the fact that he made his living by selling his paintings; this form of professionalism had become very common in the late Ch'ing. The evidence of Wang's literati spirit can be found in his three painting manuals on the subjects of rocks, bamboo, and plum blossoms, in addition to other works in different formats.[13]

Misty Landscape is representative of Wang's literati approach. It bears an inscription written in the semicursive script of calligraphy, and recalls a previous visit to Kyoto:

> Once in bygone years I moored my boat at the harbor of Kyoto on a rainy day. The cloudy mountains and misty trees were distant and indistinct as though they were from a landscape by the Master Mi. Now I recall the former trip, consigning my feelings to the brush and silk without concerning myself with the opinions of connoisseurs.

The overall composition of this work shows that Wang Yin used the three-part spatial formula which divides the painting surface into foreground, middleground, and background, as developed by the Yuan masters. The rainy scene is skillfully expressed, especially in the section in which the trees and piled-up mountains are depicted in a combination of very wet dots and lines. This style is said to have originated with the Northern Sung master Mi Fu. Nevertheless, the traditional composition and pictorial elements only served as an inspiration for Wang Yin. The cool and calm feeling accomplished through Wang's expressive brush reveals his individual character, rather than that of the old masters he followed.

In order to create a moist, atmospheric effect, Wang surrounded the mountain forms with clouds that are defined with only a few light outlines. In the foreground, the wet brush has been maintained to depict the zigzag-shaped bank and the boat, but with much clearer and brighter tones. The contrast of these tonalities emphasizes the distant and indistinct misty trees and cloudy mountains. The man sitting in the boat (probably Wang Yin himself) and the two men on the bank pulling the boat are all painted in simple and vivid brush strokes. This scene contains the essence of the entire painting, similar to a single phrase in a poem which embodies its meaning and lends clarity to the whole.

In this painting, we see not only the highly skillful technique of combining both *pi* (brush) and *mo* (ink), but also a new approach toward eclecticism. By conveying his personal expression through reinterpreting an earlier style, Wang Yin succeeded in capturing the true literati spirit.

JM

Notes

1. Records indicate that Ch'en entered the port of Nagasaki in 1827, 1838, 1839, 1840, 1841, 1843, 1847, 1848, 1849, and 1850. He may also have spent some time in Japan in 1832, and during the years 1828-32 and 1843-47. See Tsuruta Takeyoshi, "Chin Isshū to Chin Shiitsu," 63-66.

2. Nagasaki Inn was one of the places where visiting Chinese were permitted to live while in Nagasaki.

3. For additional biographical information, see Kōyama Noboru, "Okada Beisanjin-Hankōfushino," *Kobijutsu* 53 (July 1977): 52-58.

4. This was contrary to the Chinese opinion of Lan Ying in which he was regarded more as a professional painter.

5. Both Chikutō and Baiitsu were proteges of Kamiya Ten'yū, a wealthy Nagoya merchant and collector who probably owned several works by Lan. Ten'yū encouraged his students to copy Chinese paintings as their artistic training rather than apprentice themselves to a master.

6. Works by or attributed to Lan Ying with very similar compositions are in several collections, including the Yale Art Gallery and the private collections of Chih-lo Lu and Yanagi Takashi. Based on an analysis of Baiitsu's landscape paintings, Patricia Graham dates *Autumn Contentment* to 1848-49 in "Yamamoto Baiitsu: His Life, Literati Pursuits, and Related Paintings " (Ph.D. Dissertation, University of Kansas, 1984: 227).

7. This is reproduced in Suzuki Kei, comp., *Comprehensive Illustrated Catalogue of Chinese Paintings,* vol. 4, IV-477, and in Hirada Kinjurō, ed., *The Pageant of Chinese Painting,* 701.

8. See Tsuruta Takeyoshi, "Ra Setsukoku to Ko Tetsubai," 324.

9. See the "Lieh-chuan" section of the *T'ang shih* (T'ang Dynastic History). This poem might be a reference to the T'ang poet Li Ho who is said to have always traveled by donkey in his quest for poetic inspiration.

10. Tsuruta Takeyoshi, "Ra Setsukoku to Ko Tetsubai," 61-67.

11. According to *Sung Yuan Ming Ch'ing shu-hua-chia nien-piao,* edited by Kuo Wei-chu (Hong Kong: Shao Hua Weu Hua Fu Wu She), 552, 525, Wang was near sixty when he published his *Manual of Plum Painting* in the year 1889. That puts his birth year around 1829. The records in the same book show that he was still active in 1892.

12. Tsuruta Takeyoshi, "O Ya-bai ni tsuite," 1.

13. See *Sung Yuan Min Ch'ing shu-hua-chia nien-piao,* edited by Kuo Wei-chu (Hong Kong: Shao Hua Weu Hua Fu Wu She), 515, 520, 522, 525.

Part Five: Japanese Nanga

A number of paintings in the Hutchinson collection are neither by visiting Chinese artists nor directly influenced by them, but rather belong to the mainstream of Japanese Nanga. Sometimes following the styles of Chinese paintings that were imported, sometimes modeled after designs in Chinese woodblock books, and usually influenced by earlier Japanese literati traditions, these paintings demonstrate how thoroughly Chinese ideals had penetrated their new homeland. Since these literati tenets had in part been disseminated by visiting Chinese artists, Nanga cannot be understood as a totality without the impact of masters such as I Fu-chiu and Chiang Chia-p'u being taken into account.

Sakaki Hyakusen (1697–1752) is an example of an artist who developed his style more from the study of actual Chinese paintings than from other sources. In contrast, Takebe Ryōtai (1719–1774) learned not only from Hyakusen but also from Chinese artists in Nagasaki; Ryōtai further spread the influence of the visitors by publishing woodblock books of their landscape and plant designs. Nakayama Kōyō (1717–1780) seems to have modeled his art after Chinese paintings of the Wu school, but learned the styles of both Hyakusen and Shen Ch'uan in his eclectic training as an artist. This eclecticism is one of the features that distinguishes Nanga from Chinese literati art; frequently it has been inferred that the Japanese were not aware of the theoretical divisions made between scholar and professional painting by Tung Ch'i-ch'ang. It may be more to the point, however, to consider that the Japanese had no need to be bound by the shibboleths of the continent. By their free choice of models they were able to infuse the literati tradition with new energy and vitality.

A few of the Nanga masters of the early eighteenth century, such as Fūgai Honkō (1779–1847), continued the free style of such earlier artists as Taiga; however, even Taiga's own pupil Aoki Shukuya (1737–after 1806) gradually turned to the conservative literati tradition represented by the later Chinese visitors to Japan. This new orthodoxy was developed by leading artists in Kyoto such as Rai San'yō (1781–1832) and Yamamoto Baiitsu (1783–1856), both of whom were quite professional in their attitude towards earning a living through their art. Literati painting had now become an accepted and well-supported part of Edo period culture.

By the latter part of the nineteenth century, Nanga masters became bastions of conservatism in an art world shaken by new influences from the West. Masters such as Hoatari Kyōu (1810–1884) and Suzuki Hyakunen (1825–1891) tenaciously held on to literati styles of brushwork in the face of changing canons of taste. In the course of teaching at new colleges of art and displaying their own works in large national and international exhibitions, however, these painters accepted some of the new trends in the artistic world of the Meiji era.

Nanga had a lively history during two hundred years between its pioneer days in the early eighteenth century to its gradual fading away as an artistic force in the first decades of the twentieth century. Begun as an alternative to the traditional painting styles of the time, it ended as a well-entrenched tradition of its own. Visiting artists from China were influential throughout Nanga history; they first stimulated Nanga pioneers seeking a new vision, and later helped the Japanese to codify and refine conservative literati tenets of composition and brushwork. The isolationist policy of the Tokugawa government actually worked to increase the influence of the Chinese painters who made the journey to Japan; native artists were so eager to meet practitioners from the continent that they were more impressed than they would have been in a more open society. Thus the impact of the visiting Chinese painters was greater than the sheer quality of their works would suggest. By their models, teaching, and encouragement, they made a lasting contribution to the world of Japanese art.

SA

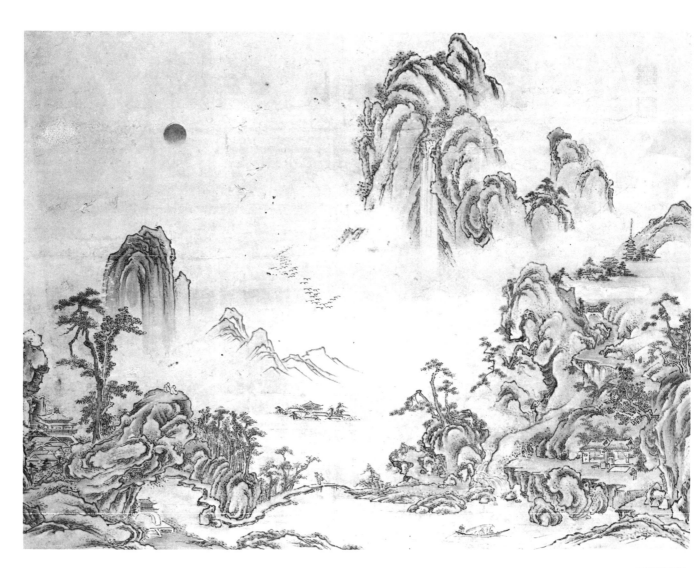

42. Sakaki Hyakusen (1697–1752)

Imaginary Landscape
Ink and color on paper, 40.2 × 53.6 cm.
Seals: Hōshin'en, Betsugō hoshū
Published: James Cahill, *Sakaki Hyakusen and
Early Nanga Painters*

Sakaki Hyakusen was born in Nagoya to a merchant family specializing in pharmaceutical products. Due to this family's economic dependence on medicinal herbs imported from the continent, he probably had many opportunities to travel to the port city of Nagasaki and to examine objects of Chinese origin which were received there. During his twenties, he was active as a haiku poet in the Ise region, but later he established a permanent residence in Kyoto. Unlike his contemporaries Gion Nankai (1677–1751) and Yanagisawa Kien (1706–1758) who painted as a means of personal expression in emulation of the scholar ideal, Hyakusen chose to support himself as a professional painter. However, probably because of his exposure to actual Chinese paintings, he was sought out by other artists interested in continental modes of expression; Ike Taiga (cat. 7, 18), Tatebe Ryōtai (cat. 43) and Nakayama Kōyō (cat. 44) may be counted among his acquaintances.

Hyakusen's oeuvre ranges from *fusuma* and screen painting, which reveal Japanese design and color sensibilities, to works which so closely resemble Chinese models as to be virtually indistinguishable.[1] Many of his landscape compositions suggest the influence of late Ming dynasty models in their subtle washes of color, convincing arrangements of compositional elements and adherence to famous literary themes. In other works, however, Hyakusen did not employ these elements. The simplified brushwork of *Imaginary Landscape,* for example, consists of heavy outlining strokes to define rock formations with a limited range of ink shading to suggest volume. The small dotting strokes which are arranged about the rocky crevices represent both the surface quality of the rocks and the low vegetation which clings to them. These strokes have been schematically applied without the careful layering and build-up of tonalities common in Chinese paintings and in Hyakusen's more sophisticated works.

Scale discrepancies and spatial ambiguities also suggest the experimental nature of *Imaginary Landscape.* The mountain range which rises above the distant village in the mist seems to exist on the same visual plane as the towering rocky mass with waterfall, but the lack of detail devoted to the former suggests greater distance from the viewer. The waterfall which issues from the mountain mass is impossibly large in comparison to the scale of the foreground scene. The trees, likewise, are drawn without strict adherence to scale; the pine, bamboo, and broadleaf grouping at the left of the composition is fantastically tall, dwarfing the buildings and rocks.

The indiscriminate use of various thematic motifs further betrays the composite nature of the work. Details such as the descending geese and the scholars who look toward a distant temple from a rocky ledge suggest imagery pertaining to the famous theme of the "Eight Views of the Hsiao and Hsiang." However, the cranes, waterfalls, and the fantastic quality of the landscape itself are elements common to paintings of the "Isles of the Immortals." The interweaving of these themes within a single composition suggests the lack of a specific model, resulting in Hyakusen's playful building of the landscape from structurally and thematically divergent parts.

Hyakusen's *Imaginary Landscape* closely parallels his undated album of scenes of mountains and cliffs.[2] The simplicity of the brush style in both works which results in a two-dimensional patterning of strokes suggests dependence on woodblock instruction manuals such as the *Hasshu gafu* and the *Mustard Seed Garden Manual of Painting.* However, given Hyakusen's obvious debt to Chinese works as revealed through the majority of his oeuvre, it has been postulated that both of these works date from the formative years of his artistic development.[3]

The early pioneers of Nanga painting in Japan are characterized by diversity of artistic interests and styles. While the multifarious nature of their known works often calls into question the extent of their knowledge of Chinese scholar painting, it may also be suggested that their enthusiasm for painting sometimes took precedence over the stringent dictates of the Chinese ideal. The most skillful and prolific of the early Nanga painters, Sakaki Hyakusen well represents this adventuresome spirit in his *Imaginary Landscape.*

MW

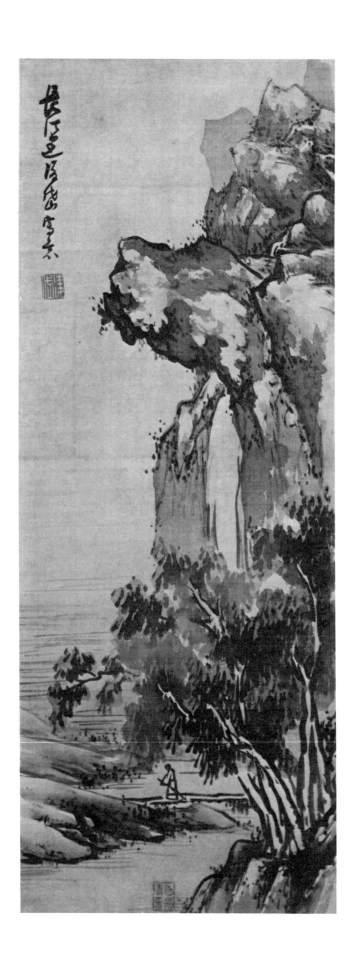

43. Takebe Ryōtai (1719–1774)

Pure Sound of the Rivers and Mountains
Ink on silk, 80.9 × 30.9 cm.
Signature: Chote Ken Ryōtai sha-i
Seals: Ryōtai, Sansui sei-on (Pure sound of the
 rivers and mountains)

Known as a painter, illustrator, poet, and novelist, Takebe Ryōtai showed his versatility in many different artistic areas. The second son of Kitamura Shoi, a retainer of the daimyo of Kirosaki, Ryōtai was born in Mutsu province. A contemporary of Ike Taiga (cat. 7, 18) and Yosa Buson (1716–1783), Ryōtai shared many of the same interests as the two masters, although there is no written evidence to indicate that he ever met them. He wrote many painting manuals, such as *Kanga shinan, Kan'yōsai gafu, Keishi gafu,* and a version of Li Yung-yun's bamboo album *Chu-p'u.*

Ryōtai was once a monk at the Rinzai Zen temple at Tōfukuji in Kyoto, but he gave up this position and devoted himself to art and poetry. In addition to receiving painting lessons from Sakaki Hyakusen (cat. 42), he studied in Nagasaki under the bird-and-flower master Kumashiro Yūhi[4] (cat. 16) and, in 1754, under the visiting Chinese painter Fei Han-yuan.[5] Fei's influence on Ryōtai can be detected in the Japanese artist's *Kanga shinan,* in which many of Fei's painting methods were illustrated. In this volume, Ryōtai also brought out three important elements of his art theory. First, one should endow paintings with a special spirit or character; second, one must be meticulous about brush technique; and finally, to compose a painting one needs to take nature as a model.

Pure Sound of the Rivers and Mountains demonstrates the influence of Fei Han-yuan's style upon Ryōtai's brushwork in a unique composition. A group of trees clustered in the lower right portion of the painting is painted with very wet strokes with an emphasis on varying tones of grey. This may have been due to the influence of Fei Han-yuan; the brushwork is free and loose in both artists' works, with ink used to create light and dark contrasts. Scattered dots in darker tonalities delineate the shapes of the rocks. The depiction of the scholar passing over the bridge adds a sense of movement to the work.

The entire composition leans dramatically to the left. Even though Ryōtai included low banks and horizontal lines which indicate the current of the river, these elements do not serve to balance the composition. It is difficult to distinguish the spatial distance between the trees and the mountain peaks which stand beyond them. Ryōtai neither emphasized the tonal differences between these two subjects nor did he separate the mountain from the trees by using the convention of a band of mist. Instead he allowed these elements to merge.

Ryōtai often utilized the dramatic effects of chiaroscuro, as is evident in the rock formation that abruptly protrudes to the left. This shape is so dominant that one can hardly tell that there is a waterfall beneath it. Because of the powerful composition, the overall effect of the painting is overwhelming. The free and powerful brushwork expresses Ryōtai's literati ideals as he indicated in the inscription *sha-i* (expressing the spirit), and further explained in his painting theories. He depicted nature by reinterpreting it in his own manner. By placing emphasis on brush and ink rather than painstakingly copying the natural world Ryōtai achieved an original vision.

JM

結茅栽樹傍巖幽避跡甘從應鹿
遊屋外青山通短徑門前修竹蔭
寒流看雲時隱烏攸几對客開枕
鶴覽嶔嶔應是淮南招隱地西風蕭
瑟桂叢秋
右明梁公實題隱居圖詩
安永丙申孟冬
東江源鱗書

高陽外史人寫

44. Nakayama Kōyō (1717–1780)

Living by a Secluded Cliff
Ink and light colors on silk, 96.6 × 32.3 cm.
Signature: Kōyō sanjin
Seal: Teichū/Shiwa[6]
Inscription by Sawada Tōkō (1732–1796) dated
 1776
 Signature: Tōkō Genrin
 Seals: Raikin, Tōkō Genrin
Published: Kao Mayching, *Literati Paintings from
 Japan,* no. 12.

The art of Nakayama Kōyō exemplifies the intellectually curious and experimental nature of early Nanga. Kōyō learned Chinese styles of painting through the study of woodblock books and made more than 500 copies of old Chinese paintings, particularly those in Sung and Ming dynasty styles. Like his contemporary Yosa Buson (1716–1783), Kōyō may have been a pupil of the Nanga pioneer Sakaki Hyakusen (cat. 42), as well as learning the academic style of Shen Ch'uan (cat. 15) for bird-and-flower compositions. This eclectic approach enabled Japanese painters such as Kōyō to achieve new combinations of styles that would have been unlikely if not impossible in China.

Kōyō painted a wide range of themes, becoming most known for his figure subjects and scenes from Chinese history and legend. He probably did not begin painting traditional literati landscapes until the age of forty. This rather conservative work from his late years bears a poetic inscription by the well-known calligrapher Sawada Tōkō, who became a friend of Kōyō in Edo (Tokyo) and inscribed several of his paintings.

Tōkō has written "a poem by Liang Kung-shih of the Ming dynasty which was inscribed on the painting 'Living as a Hermit.'"

> Building a thatched hut and planting trees by a secluded cliff,
> I follow the wandering deer, hidden from the world of men.
> Outside my hut, green mountains lead to a short pathway;
> In front of my door, groves of slender bamboo keep the cold at bay.
> Leaning on my black leather table, I can gaze at the clouds,
> Entertaining visitors, I leisurely don my crane-feather coat.
> This place where I live is the hut of a Taoist hermit;[7]
> Here the desolate west wind brings autumn to the osmanthus bushes.

Below the calligraphy, a mountainous landscape looms over a scene reminiscent of the poem; deer play in the enclosure of a yard, while a guest and his boy servant approach over a nearby bridge. The delicacy of the brushwork, like that of the calligraphy, emphasizes the quiet dignity of the scene. Although little depth is apparent in the painting, atmospheric perspective is created through light washes of blue on the distant mountain and under the leaves of the tree and the bamboo. Tints of orange-pink on the house, rocks, and deer complement the blue tonalities. Outlines are generally light and there are relatively few texture strokes, serving to maintain a sense of peace and tranquility.

The painting, poem, signatures, and seals all help to balance the total composition by interacting with the mood of the poem and landscape in an appropriately literati manner. Although in other works Kōyō was more experimental, here he and his friend Tōkō have mutually produced a refined and lyrical expression of an age-old Chinese ideal: man and nature become unified through the arts of painting, poetry, and calligraphy.

BJ

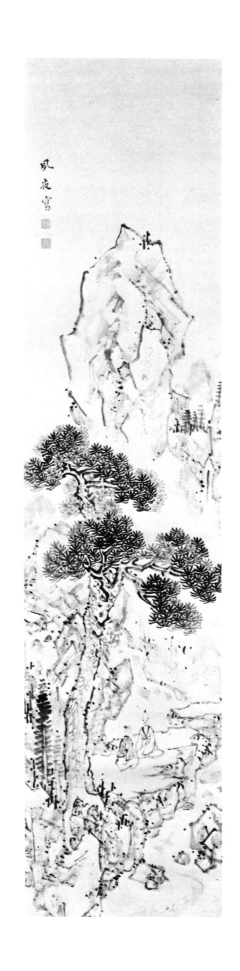

45. Aoki Shukuya (1737–after 1806)

Scholarly Communion
Ink on paper, 114.8 × 27.4 cm.
Signature: Painted by Shukuya
Seals: Yo Shummei, Yo Shukuya, Gen'un suikyō ?

Beyond the vicissitudes of time, a number of factors have contributed to the lack of artistic recognition for and information about Aoki Shukuya. By far the largest is the overshadowing fame of his teacher and mentor, Ike Taiga (cat. 7, 18). Shukuya showed a lifelong devotion to Taiga, first as his pupil and later as the caretaker of the Taigadō, a hall established where Taiga had lived within the precinct of the Sorinji. This has tended to encourage the concept of Shukuya as a posthumous extension of his master. Artistically, Shukuya is known to have produced a number of works which owe an obvious debt to Taiga, further justifying this evaluation. While it has been pointed out that Shukuya also painted in a style closely related to the mid-Ming Su-chou painters in technical finesse, the delicate and unobtrusive nature of these works undoubtedly ensured their lack of notice. Only Tanomura Chikuden (1777–1835) in his *Sanchūjin jōsetsu* (Chit-chat of a Mountain Hermit) recognized this conservatism as evidence of Shukuya's individual maturation as an artist.[8]

Shukuya was born in Ise, but became part of the Aoki family of Kyoto. Kan Tenju (cat. 5), Shukuya's older cousin who was adopted into the Nakagawa family of merchants, is thought to have been responsible for introducing Shukuya to Taiga. Both Tenju and Shukuya are thought to have descended from Korean origins; Tenju probably adopted the "Kan" portion of his name from the character for the name of Korea, "Kankoku," while Shukuya used the character "Yo" as a family name (the same character used by the Mahan king Yo Yang Wang).[9]

Beyond these facts, little is known concerning the details of Shukuya's life. After Taiga's death, it was Shukuya who maintained the Taigadō, caring for and copying paintings by his master and functioning as a connoisseur of his works. It is impossible to substantiate Chikuden's account of Shukuya as a recluse who was melancholy over the death of Taiga. However, the fact that he lived in the Taigadō enveloped by the remaining vestiges of his master's life would have further served to inextricably bind his personal accomplishments to Taiga. The exact date of Shukuya's death remains a puzzle, and the location of his grave is still unknown. From information in the *Sanchūjin jōsetsu,* it has been postulated that he died shortly after the re-opening of the Taigadō, some ten years after Taiga's death in 1776. However, the existence of works by Shukuya dated to 1802 disproves this theory. More recent evidence suggests that he was active as late as 1806.[10]

In *Scholarly Communion* two gentlemen sit facing each other beneath an ancient pine. In their relaxed postures, they seem oblivious to the enlivened landscape forms which surround them. Crystalline rocks brushed in dry, scratchy strokes push threateningly in every direction. The surface of the painting dances with a scattering of black dots. Even the vegetation is rhythmic, with staccato patterns created by the pine needle clusters, vertical twigs, and horizontal dabs of ink for foliage.

This painting is indicative of Shukuya's work after Taiga, revealing his skill as a painter. While often dismissed as a less brilliant reflection of his master, in paintings such as *Scholarly Communion* Shukuya managed to recapture much of the playful genius of Taiga's brushwork. Even the manner of holding the brush, evident in the variations of line width resulting from a slanted brush tip, is in accordance with Taiga's methods. In Shukuya's more conservative works, the dry brush quality seen in this painting is further developed, creating delicate layers of rich texture and adding subtle volume to rock formations. Thus, *Scholarly Communion* evinces both the vibrancy of Taiga's vision and a glimmer of Shukuya's personal style.

MW

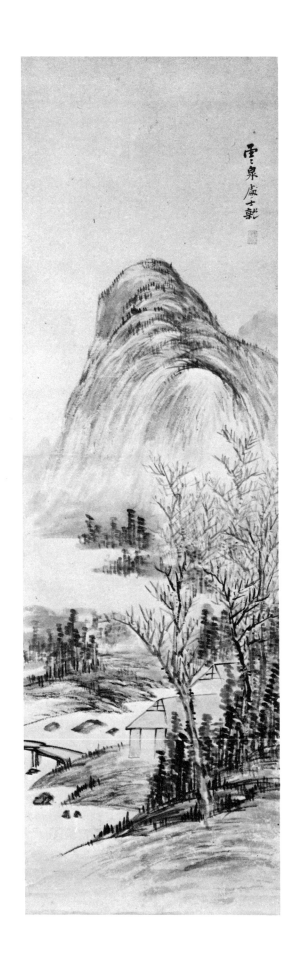

46. Kushiro Unsen (1759–1811)

River Hermitage in Autumn Mists
Ink on paper, 96.3 × 29.7 cm.
Signature: Unsen shoshi shū
Seal: Ransei Shū

Unsen was born in Shimabara on Kyushu, but at an early age he was taken to Nagasaki by his father. As the hub of sanctioned trade with other countries, this port city afforded young Unsen direct contact with foreign visitors. He is known to have learned the Chinese language and is thought to have studied continental modes of painting during this period. After his father's death, he traveled widely, perhaps emulating the unfettered lifestyle of famous retired officials of the Sung and Yuan dynasties. In the neighboring cities of Kyoto and Osaka, he associated with the sake brewer and patron of the arts, Kimura Kenkadō (1736–1802), as well as the artists Totoki Baigai (1749–1804), Uragami Shunkin (1779–1846) and Rai San'yō (cat. 49). In Edo he met Kameda Bōsai (cat. 10, 11), Tani Bunchō (1763–1840), and their friend the poet Ōkubo Shibutsu (1766–1837). In this manner, Unsen completed a circuit which brought him into contact with the most noted Sinological scholars and painters of the period.

A true literati spirit, Unsen preferred his solitary wanderings to the bustle of city life. In his later years, he moved to the scenic and remote region of Echigo in Niigata to live as a recluse. Although his reputation as a painter caused many to seek him out, Unsen was unconcerned with fame and worldly fortune, often passing his days in fishing excursions.

Given the broad scope of Unsen's exposure to contemporary painting, it is not surprising that his style is richly varied. He adopted a wide range of subject matter including orchid and plum paintings as well as his more widely known landscape compositions.[11] *River Hermitage in Autumn Mists* suggests something of the bland purity of Ni Tsan (1301–1374) but more closely resembles late Ming and Ch'ing recensions of the earlier master's style. The low, rounded mountain shape and horizontally dotted saplings encourage comparison to the works of Fei Ch'ing-hu, a merchant who visited Japan repeatedly between 1787 and 1806. Although Fei was best known for his paintings in the style of Mi Fu, he also brushed quiet river landscapes which may have served as models for Unsen. Here Unsen has rendered his land masses through a series of short dry strokes, underscored by wet grey washes. The sketchy quality of these forms, together with the trees which divide into an ambiguous mass of interwoven twigs, suggests that this work belongs to the formative period of Unsen's artistic development. While lacking the monumentality and power of his more resolutely painted compositions, this quiet landscape reflects Unsen's formalistic and studied approach to landscape painting. By placing little emphasis upon dramatic or realistic effect, Unsen clearly worked within the scholar-amateur tradition.

MW

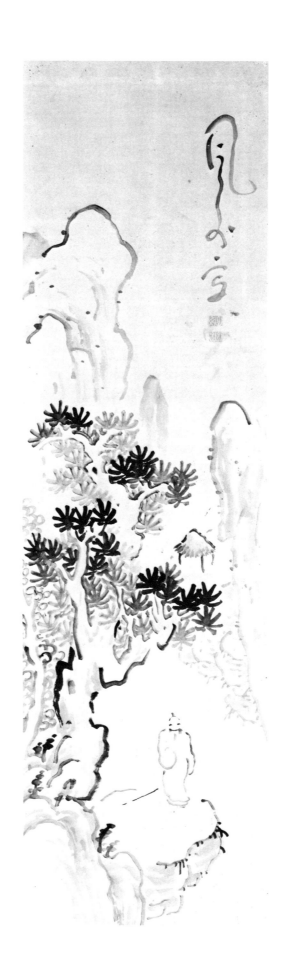

47. Fūgai Honkō (1779–1847)

Mountain Wandering
Ink on paper, 100.6 × 29.5 cm.
Signature: Painted by Fūgai
Seals: Kō/yū

Artistic production within the Nanga world during the early nineteenth century is best understood in terms of the conservative trend espoused by Rai San'yō (cat. 49) and the painter-theorists Tanomura Chikuden (1777–1835) and Nakabayashi Chikutō (1776–1853). During this period Japanese scholar-painters attempted to emulate Chinese literati culture and to approximate the restrained brush modes of continental artists of the Southern school. As opposed to this tendency, the oeuvre of Fūgai Honkō represents a final tribute to the whimsically unorthodox style of Ike Taiga (cat. 7, 18) which had fallen from vogue during the latter years of the eighteenth century.

Born to a poor family of farmers in a small village near Ise, Fūgai entered a Buddhist monastery at the age of eight and was ordained as a priest of the Sōtō sect at thirty, eventually succeeding his teacher Genrō Ōryū (1720–1813). As was common for monks and priests, Fūgai traveled widely and held several ecclesiastical posts before settling down to one position in his latter years. During one of his sojourns to the Matsue area near Izumo, Fūgai is said to have come into contact with a large number of paintings by Ike Taiga. In 1755 Taiga had visited the Tenrinji, Eitokuji, and Sogenji in this area and seems to have had some connection to the Katsubei family who lived near the Eitokuji.[12] Over fifty years later, when Fūgai examined paintings by the master in this area, he must have felt a timeless bond with Taiga.

While it is somewhat unusual that Fūgai chose to follow the Nanga movement rather than contemporaneous Zen artistic styles, his careful study of Taiga's paintings and the abundant apocrypha surrounding the memory of the master suggests something of the "transmission of the mind" so important within the Zen sect. From this time, Fūgai resolutely sought to rekindle the spirit of Taiga within the simplicity and spontaneity of his own paintings.

In *Mountain Wandering,* a solitary sage seems joyfully self-satisfied as he unabashedly stares back at the viewer from his position on a tiny plateau. An ancient pine arches over his head and dominates the composition while bulging mountain shapes push in from either side, echoed by Fūgai's distinctive calligraphy. The uneven inking and slanted brush outlines are hallmarks of Taiga's style, as is the tonally varied patterning of the pine needles. The painting notably lacks the calculated quality of Taiga's more immediate followers in the second half of the eighteenth century. Instead, Fūgai's genius is evident in his simplicity of composition and bravura of execution while formally following the artistic wellspring of Ike Taiga.

MW

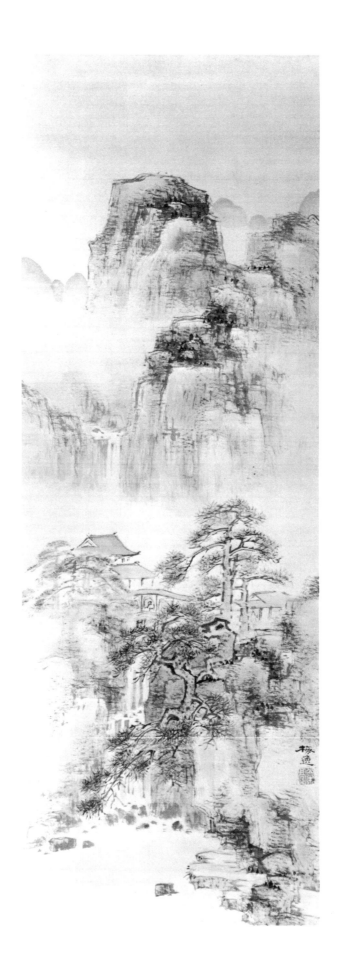

48. Yamamoto Baiitsu (1783–1856)

Landscape with Pines
Ink and colors on silk, 111.8 × 39.9 cm.
Signature: Baiitsu
Seals: Yamamoto Ryō

Yamamoto Baiitsu, well-known as a Nanga artist from Nagoya, has long been famous for his professional bird-and-flower depictions. Recently, however, Baiitsu's literati paintings and interests have been reevaluated.[13] *Landscape with Pines* is a superb example of Baiitsu's literati spirit seen through his romantic and personal view of nature.

This work of Baiitsu's mature period shows the result of the artist's careful study of Chinese painting styles. The influence of the Yuan dynasty master Ni Tsan can be detected, particularly in the depiction of the rocks. In addition, the style of the seventh-century artist Hung Jen may also have influenced Baiitsu's work. One of the "Four Masters of Anhui," Hung Jen is known for his spare, geometric mountain shapes and his use of the motif of a dramatic pine tree, similar to the one used as a central focus here by Baiitsu. It is not certain, however, whether Hung Jen's works were known in Japan at this time.

Although Baiitsu utilized elements from Chinese painting for *Landscape with Pines,* he has reorganized them to create his own statement about the natural world. Here he has depicted a frozen slice of time. A scholar, passing through a covered bridge, pauses a moment to admire the beauty of a waterfall. There is the sense that the man crosses this path often and that he is familiar with the beautiful view. We are given a glimpse of a world where man blends with and understands the majesty of nature, rather than being overwhelmed by it. The calm, tranquil feeling of the scene denies even the sound of the waterfall.

At first glance, the boldly gnarled pine dominates the foreground. Growing precariously downward over a pool of water with roots clinging to the edge of the cliff, this pine adds a note of drama to an otherwise subdued scene. One of the "three friends of winter," the pine is also associated with long life. Baiitsu was fond of such themes and was noted especially for his strongly composed and delicately rendered pines. In this painting, the endurance required for the tree to grow in this strange position may be associated with its perennial quality.

The deep tones used to depict the pine are balanced by the darkness of the rocks in the extreme foreground and the mountains in the background. The use of dark ink denies a true sense of spatial recession.

However, Baiitsu does make a clear distinction between the foreground group of three pine trees and the less dominating forms of the houses and bridge, the middleground of blank space alluding to mist, and the background of two mountain crests. The total composition leads the viewer from the pines of the foreground up to the mountains, down the waterfall, and finally to the scholar. The viewer is encouraged to take a leisurely journey through the painting, for he may miss some essential element if he hurries.

The softness of feeling in this painting is brought forth primarily through feathery dry brush strokes and the application of delicate color. This light touch was also utilized by Baiitsu's friend Nakabayashi Chikutō, whose influence may also be seen in the bulging rectangular rock forms. These rocks were rendered with a very dry brush, creating multiple outlines. They were then filled in with short strokes of varying colors to suggest facets, giving them a sparkling quality. In contrast, the pine needles are characterized by crisp, quick strokes slightly softened by the addition of light green color.

The caliber of Baiitsu's artistry can be seen in his ability to balance the complex composition of *Landscape with Pines* perfectly, yet in a manner which seems effortless. Obviously, the advice of his mentor Kamiya Ten'yū to study Chinese painting styles served Baiitsu well. In this painting, Baiitsu has demonstrated not only that he mastered Chinese techniques, but also that he captured the true literati spirit by expressing his own refined personality through his brush.

LJ

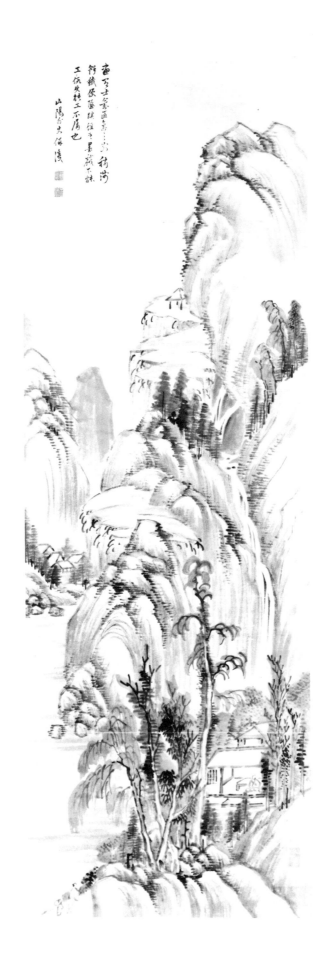

49. Rai San'yō (1781–1832)

Scholarly Retreat Beneath Rocks and Cataracts
Ink in paper, 130.3 × 45.1 cm.
Signature: San'yō gaishi heishiki
Seals: Jōin, Shise, Kan'un kokaku katen (A single
 crane between the clouds, where better to fly
 than in the heavens)
Published: *Rai San'yō* of *Bunjinga suihen,* vol. 18

An unusual combination of erudite brilliance and a nonconformist personality caused Rai San'yō to become the leader of scholars and Sinologists in Kyoto during the early nineteenth century. As the son of the Confucian scholar, poet, and calligrapher Rai Shunsui (1746–1816), San'yō was encouraged to pursue Chinese studies. While his adolescence and early adulthood were marred by repeated instances of rebellion and a disastrous marriage, he still managed to excel in his literary pursuits. After traveling to Kyoto without permission from the local government, he was placed under house confinement. Though he undoubtedly chafed under such conditions, he began writing his *Nihon gaishi,* a history of Japan written in an elegant Chinese prose style. When his period of incarceration was over, he studied with Kan Chazan (1748–1827), a specialist in Chinese poetry. In 1811, San'yō secured formal permission to live in Kyoto and opened his own Confucian academy within the capital, thus embarking on a career that earned him the most respected position among Kyoto *bunjin.*

In true literati fashion, San'yō began painting purely for personal enjoyment. Although he studied at first with the Shijō artist Kawamura Bumpō (1749–1812), it was inevitable that San'yo should turn toward the scholar-painting tradition of China. While he surely came into contact with many paintings from the continent, he developed a distinctive style of his own. His works are characterized by a bold use of the brush within rather orthodox and conventionalized compositions. This style was in keeping with the increasingly conservative trend of Nanga at the turn of the century.

San'yō's style is readily apparent in *Scholarly Retreat Beneath Rocks and Cataracts.* Horizontal dabs of ink and long bold texturing strokes define the bulging mountain shapes that are schematically arranged toward the highest peak. The tall trees, which visually unite the rocks and pavilion of the foreground with the background mountains, are rendered in a rough, almost abbreviated manner. This type of interplay resulted in landscapes whose appreciation depended upon the strength and character of the artist's brushwork rather than on innovative compositional arrangements or meticulous brush techniques.[14] In his inscription, San'yō clearly identifies himself with the Southern school or scholar-amateur tradition advocated by the late Ming painter-theorist Tung Ch'i-ch'ang (1555–1636).

> In painting there is a difference between those of
> high spirit and those who seek to impress.
> If painting becomes fine and delicate, it will be narrow and limited.
> My ink-play should not be laborious.
> Should it ever become so, I will throw it away.

MW

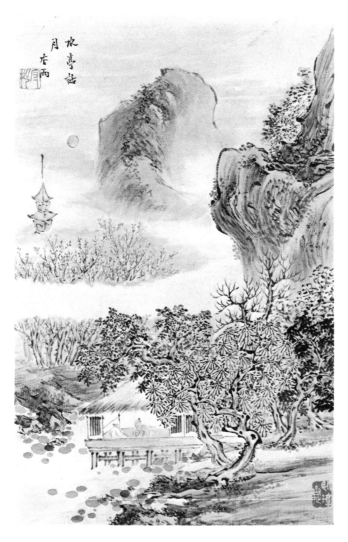

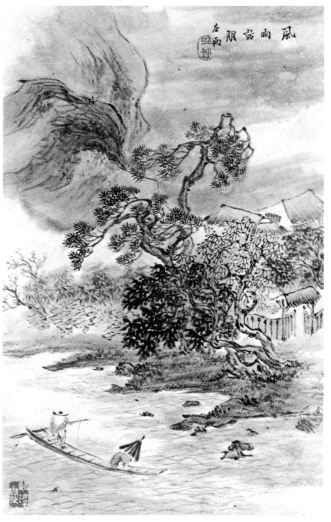

50. Hoatari Kyōu (1810–1884)

Landscape Album, 1840
Ink and color on paper, each leaf 23.5 × 15.3 cm.
Signatures: Kyōu
Seals: Shusetsu, Gayūsai, Chōshū
Published: Howard Link (ed.), *Asian Orientations*

Painted when the artist was thirty years old, this twelve-leaf album is one of the earliest extant works by Kyōu. Born the son of a rich farmer in Hetsugi on the southern island of Kyushu, Kyōu came under the influence of the Nanga master Tanomura Chikuden (1777–1835) in 1824. At Chikuden's suggestion, Kyōu journeyed to Kyoto at the age of twenty to study the Confucian classics, poetry, and painting with Rai San'yō (cat. 49), Shinozaki Shōchiku (1781–1851), and Uragami Shunkin (1790–1846). After returning to Kyushu, Kyōu began painting extensively, primarily in the style of Chikuden but also following various Yuan and Ming dynasty traditions. He had a long and successful career, exhibiting at the International Exposition in Vienna in 1872, but after he lost the sight in one eye in 1879 he painted very little until his death five years later.

This 1840 album, produced five years after Chikuden's death, came during a period when Kyōu was paying homage to his master. Two years previously Kyōu had published a collection of Chikuden's painting inscriptions; in 1842 Kyōu was to organize a major exhibition of Chikuden's works. It is therefore not surprising that these album leaves show strong influence from Chikuden, but they also reveal characteristics of Kyōu's personal style.

The first leaf in the album, entitled *Conversation under the Moon in the Waterside Pavilion,* reveals a yellow moon illuminating a landscape where scholars sit in a hut overlooking a lotus pond. Although some leaves in the album are painted entirely in ink, this leaf contains an array of colors including pinks, blue-greys, blue-greens, greenish browns and dots of green over dots of black. The composition is atmospheric; a band of mist cuts the middleground trees in half, and the top of a pagoda looms above them. Although the landscape forms are boldly presented, the mood is serene, with restrained brushwork depicting the quiet intimacy of friendly conversation.

Green-over-black dots are also found in the second leaf, *Visiting a Friend Amid the Wind and Rain,* where they serve to provide texture and complement the accents of black ink throughout the painting. Behind a man guiding his boat through the water, grey washes form clouds hovering over the mountains. Touches of blue-green which define the land masses are juxtaposed with pinks in the tree trunks and the village huts. The sense of windy rain is effectively conveyed by the huddled figures in the boat, the twisting and swaying trees, and the grey texturing of the land and sky. Strong diagonals dominate the composition, which thus contrasts with the tranquility of the preceding leaf, but once again the brushwork is light and feathery.

The gentle and delicate touch seen in these two leaves continues throughout the album, revealing the influence of Chikuden. The various paintings, however, have a variety of ink usage and texture strokes that testify to Kyōu's expertise with the brush and his strong interest in ink tonalities. These characteristics continued to appear in his work until his final years; Kyōu can be considered one of the most important artists who preserved traditional Nanga values after the Meiji Restoration of 1868. This early album demonstrates that the poetic and lyrical mood that Kyōu achieved in his painting was not only his heritage from Chikuden, but also his own individual characteristic as revealed through his brushwork.

BJ

51. Suzuki Hyakunen (1825–1891)

Ink Landscape
Ink on satin, 125.3 × 36.8 cm.
Signature: Hyakunen
Seals: Suzuki Seiju (upside-down), Hyakunen

Historians often deal with the Meiji era (1868–1912) as if the fascination with the West overshadowed all conservative aspects of Japanese culture. Certainly it was a period of dramatic change and upheaval when Western science, education, and art were avidly studied and incorporated into the Japanese way of life. Nevertheless, there were many painters who adhered to the traditions of the past. Particularly in the early years of the Meiji era, scholar-artists defended the Nanga style of painting against the challenges from abroad.[15]

Suzuki Hyakunen is only beginning to be known as a Nanga master of this period, in part because he turned to Nanga only after specializing in landscapes in the Shijō tradition for many years. The son of Suzuki Tosho, a pioneer Japanese astronomer in Kyoto, Hyakunen studied with Yokoyama Kakei (1816–1864) and was influenced by Ōnishi Chinnen (1792–1851), both of the Shijō school, and also explored various Japanese and Chinese styles of painting. Achieving some success in his middle years, Hyakunen won awards at the first and second exhibitions of the Naikoku kaiga kyōshinkai (Society for the Encouragement of National Art). He also taught for a time at the Kyoto Prefectural School of Painting, thus contributing to the preservation of traditional styles of art.

Hyakunen's *Ink Landscape* is fully in the Nanga style, featuring aspects of Meiji taste which include strong brushwork, rich ink tonalities, and bold forms. There is little build-up of brush strokes in the foliage and a lack of atmospheric perspective, suggesting an emphasis on surface design. Closer inspection reveals some ink tonalities have been made more subtle by the medium of satin, which tends to extend the ink tones and blend them together along the threads of the material. Pale washes of ink are overlaid by long vertical grey brush strokes which create the mountains. These are then overlaid with darker grey strokes and black accents to suggest texture, as well as some outlining. As many as four layers of ink define the rocks and ground areas, with shades ranging from light grey to black. In contrast, blank satin sets off the area where a man sits in a hut overlooking a waterfall. Two trees loom over his solitary dwelling, where he remains serene amid the vast forces of nature.

The rich use of ink throughout the work serves to unify the thrusts of the diagonals and helps return the viewer's eyes to the surface of the painting. Hyakunen has deliberately emphasized the bold play of the brush, which holds for him a timeless value. This work thus represents a steadfast adherence to literati values during the turbulence of the Meiji era. The poem adds to the sense of literati unworldliness, contrasting Hyakunen's serenity of spirit with the hectic pace of those who try to fulfill their ambitions.

> Penetrating my bamboo blinds, the green of many
> layers of mountains;
> Sitting quietly all day, I watch the clouds passing to
> and fro.
> Those who search for advancement compete in every
> way—
> In their entire lifetimes, they can never know true
> leisure.[16]

BJ

八月九日正長夜
懷丁嶠廿斗星前橫旅雁
雲坪

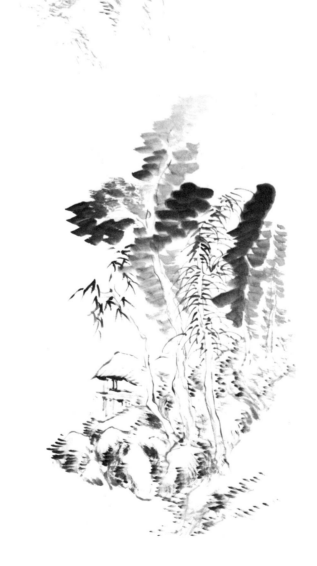

52. Nagai Unpei (1833–1899)

Autumn Landscape
Ink on paper, 131.1 × 45.9 cm.
Signature: Unpei
Seals: Kyu?, ?kōshin
Published: Stephen Addiss, "Japanese Literati
 Artists of the Meiji Period," fig. 8.

When Okura Uson (1845–1899) suggested to his friend Nagai Unpei that he should move from his rural hermitage in Shinshu to the capital in order to better support his wife and children, Unpei is said to have gone pale in dismay. His response, "orchids are fragrant even in deep ravines,"[17] compared his modest existence to the blossoms of the Oriental orchid (epidendrum), a plant which has long been symbolic of scholarly virtue and seclusion. After Uson had departed, Unpei had his wife ritually purify their house by scattering salt, and he washed out his ears in hopes of removing all memory of the tainted suggestion put forth by Uson. Such stories suggest the moral rectitude of Unpei, who lived his life in poverty while striving to emulate the lofty ideals of Chinese scholar-artists.

Born in Echigo, Unpei made his way when he was sixteen to Nagasaki where he studied with Hidaka Tetsuō (cat. 31, 32) at the Shuntokuji. Tetsuō was instrumental in introducing Unpei to Kinoshita Itsuun (cat. 33) with whom Unpei developed a deep and personal relationship which lasted until Itsuun's untimely death in 1866. Unpei's interest in China and the scholar painting tradition was undoubtedly heightened through his contact with these men, both of whom had been students of Chiang Chia-p'u (cat. 27, 28). With the financial help of an American visitor, Unpei augmented his knowledge by undertaking a voyage to China in the company of other Nanga adherents such as Yasuda Rōzan (1830–1882). In China he met the artists Hsu Yu-t'ing, Wang Tao-jen and Lu Yin-hsiang before returning to Japan in 1869. After living for a short time in Tokyo, he moved to Shinshu where he married and raised his family. Despite his poverty, he is known to have traveled widely from his rural hut, including another trip to Nagasaki and an extended stay in the mountains of Togakushi where he produced paintings of monkeys.

While more simplified than many of Unpei's compositions, *Autumn Landscape* reveals the loose, unstudied style of his brushwork.[18] The repetitive layering of horizontal accent strokes and the long, wavering outlines of the tree trunks and rocks are reminiscent of the works of Unpei's first known teacher, Hidaka Tetsuō. While the bold conception of *Autumn Landscape* is indicative of Japanese Nanga painting of the nineteenth century and bears little resemblance to the refined brushwork of Chinese artists such as Chiang Chia-p'u, Unpei's purposefully inelegant style links him to the Chinese ideal of nonprofessionalism which he clearly understood and tried to emulate. The poetic inscription, unusual in that it is in three lines of Chinese characters,[19] further reveals something of Unpei's distant and pure spirit:

> In the eighth and ninth month, the nights grow long
> The sounds are unceasing in the autumn evenings
> Traveling geese fly diagonally before Northern
> stars.[20]

MW

Notes

1. For more discussion, see James Cahill, *Sakaki Hyakusen and Early Nanga Painting.*

2. All ten leaves of this album are published in *Shoki nanga ten* (a special exhibition held at the Sano Museum of Art).

3. James Cahill, *Sakaki Hyakusen and Early Nanga Painting,* 60.

4. Ikeda Tsunetaro, *Nihon shoga kotto daijiten* (Tokyo: Kaukōkai, 1929), 474.

5. Tsuruta Takeyoshi, "Hi Kangen to Hi Seiko," 75.

6. This seal was given to Kōyō by a nephew; Teishū Shiwa was a name adopted by the artist in 1769.

7. Tōkō refers specifically to the Han dynasty Taoist hermit Liu An and his book the *Huai nan tzu.*

8. See Matsushita Hidemaro, "Aoki Shukuya: Ike Taiga no shū-hen," *Nanga kenkyū,* Vol. 3, #6 (Ike Taiga tokushū 26) (1959), 5–10.

9. Adams and Berry, *Heart Mountains and Human Ways: Japanese Landscape and Figure Painting,* 48.

10. A record written by a certain Michimasa (see cat. 4) mentions that Shukuya, in need of funds (possibly for repairs at the Taigadō), wanted to sell some of Taiga's paintings. Michimasa loaned his friend, the doctor Hagino, the money to secure the paintings. However, Hagino died in 1806, before repaying his debt. Because Shuku-ya felt he had caused Michimasa to lose money, he gave him a painting by I Fu-chiu.

11. For additional reproductions of paintings by Unsen see Ōmura Saigan (ed.), *Unsen ibokushū.*

12. Takeuchi Shōji, *Kinsei no zenrin bijutsu,* vol. *Nihon no bijutsu* (Tokyo: Shibundō) 72.

13. See Patricia Graham, *Yamamoto Baiitsu: His Life, Literati Pursuits, and Related Paintings.*

14. While *Scholarly Retreat* clearly represents San'yō's style, slight discrepancies in the placement of the horizontal Mi dots, a certain tentative quality about the calligraphy and variant seals suggest the painting may possibly be an extremely skillful copy.

15. See Stephen Addiss, "Japanese Literati Artists of the Meiji Period" in *Essays on Japanese Art.*

16. Translation by Stephen Addiss.

17. Furukawa Shū, *Nanga ronsui,* 265. All further biographical information about Unpei mentioned in this entry has been taken from this volume, 252–268.

18. Additional examples of Unpei's work are published in *Nihonga taisei* vol. 22, including paintings of monkeys and orchids.

19. Chinese regulated verse is traditionally written in even-numbered lines.

20. Translation by Stephen Addiss.

Selected Bibliography

Adams, Celeste and Berry, Paul. *Heart Mountains and Human Ways: Japanese Landscapes and Figure Painting.* Houston: Museum of Fine Arts, 1983.

Addiss, Stephen. *Nanga Paintings.* London: Robert G. Sawers Publishing, 1975.

Addiss, Stephen. *Obaku: Zen Painting and Calligraphy.* Lawrence, Kansas: Spencer Museum of Art, 1978.

Addiss, Stephen. *The World of Kameda Bōsai.* New Orleans and Lawrence, Kansas: New Orleans Museum of Art/The University Press of Kansas, 1984.

Addiss, Stephen. "Japanese Literati Artists of the Meiji Period" in *Essays on Japanese Art.* London: Robert G. Sawers Publishing, 1982.

Asano Nagatake, Kobayashi Yukio, and Hosokawa Moritatsu, eds. *Genshoku Meiji hyakunen bijutsukan.* Tokyo: Asahi Shimbunsha, 1967.

Ban Kōkei. *Kinsei kijin den.* 1790. Reprint. Tokyo: Iwanami Shoten, 1940.

Cahill, James. *Sakaki Hyakusen and Early Nanga Painting.* Berkeley: Institute of East Asian Studies, 1983.

Cahill, James. *Parting at the Shore.* New York and Tokyo: Weatherhill, 1978.

Chang, Aloysius. *The Chinese Community of Nagasaki in the First Century of the Tokugawa Period.* Ann Arbor: University Microfilms, 1970.

Contag, Victoria and Wang Chi-chien. *Seals of Chinese Painters and Collectors.* Hong Kong: Hong Kong University Press, 1966.

French, Cal. *Through Closed Doors: Western Influence on Japanese Art 1639-1853.* Rochester, Michigan: Meadowbrook Gallery, 1977.

Furukawa Shū. *Nanga ronsui.* Tokyo: Chiheisha, 1944.

Graham, Patricia. *Yamamoto Baiitsu: His Life, Literati Pursuits, and Related Paintings.* Ann Arbor: University Microfilms, 1983.

Harada Kinjirō, ed. *The Pageant of Chinese Painting.* Tokyo: Ōtsuka Kōgeisha, 1959.

Kao Mayching. *Literati Paintings From Japan.* Hong Kong: Chinese University of Hong Kong, 1974.

Koga Jujirō. *Nagasaki gashi iden.* Nagasaki: Taishōdō Shoten, 1983.

Link, Howard, ed. *Asian Orientations.* Honolulu Academy of Arts, 1985.

Mitchell, Charles H. *Biobibliography of Nanga, Maruyama, Shijo Illustrated Books.* Los Angeles: Dawson's Book Shop, 1972.

Nagami Tokutarō. *Nagasaki no bijutsushi.* Tokyo: Natsukandō, 1974.

Nagasaki kei nanga ten. Mishima: Sano Bijutsukan, 1984.

Nishi Kinseki. *Nagasaki kokon gakugei shoga hakuran.* Tokyo: Tosho Kankōkai, 1919.

Ōmura Saigan, ed. *Unsen ibokushū.* Osaka: Hōko Shoin, 1923.

Rogers, Howard. "Beyond Deep Waters." *Sophia International Review* 7 (1985): 15-37.

Shoki nanga ten. Mishima: Sano Bijutsukan, 1978.

Sō Shiseki. *Sō Shiseki gafu.* Edo: Suwaraya, 1765.

Suzuki Kei, comp. *Comprehensive Illustrated Catalogue of Chinese Paintings.* Tokyo: University of Tokyo Press, 1983.

Takeuchi, Melinda. "Ike Taiga: A Biographical Study," *Harvard Journal of Asiatic Studies* vol. 43, no. 1 (June 1983): 141-186.

Taniguchi Tetsuyū. *Nishi Nihon gadan shi.* Fukuoka: Shukokai, 1981.

Toda Teisuke. "Chinese Painters in Japan" in Yoshiho Yonezawa and Chu Yoshizawa, *Japanese Painters in the Literati Style* (translated by Betty Iverson Monroe), 156-169. New York and Tokyo: Weatherhill/Heibonsha, 1974.

Toda Teisuke. "Chōshin to Chōkon," *Kokka* 891 (June, 1966): 24-34.

Tsuruta Takeyoshi. "Hō Sai hitsu fugakuzu to hyōkaku kishōzu," *Kokka* 1031 (1980): 25-34 and supplement *Kokka* 1042 (1981): 39-44.

Tsuruta Takeyoshi. "Ra Setsukoku to Ko Tetsubai," *Bijutsu kenkyū* 324 (June, 1983): 23-29.

Tsuruta Takeyoshi. "Chin Isshū to Chin Shiitsu," *Kokka* 1044 (Aug., 1981): 34-41.

Tsuruta Takeyoshi. "Hi Kangen to Hi Seiko," *Kokka* 1036 (July, 1980): 15-24.

Tsuruta Takeyoshi. "O Ya-bai ni tsuite—raihaku gajin Kenkyū," *Bijutsu kenkyū* 319 (March, 1982): 1-11.

Tsuruta Takeyoshi. "I Fukyū to Ri Yōun," *Bijutsu kenkyū* 315 (December, 1980): 16-27.

Tsuyoshi Baba. *Nagasaki o otozuretta Chugokujin no kaiga.* Nagasaki: Nagasaki Prefectural Museum, 1973.

Ueno Tadashi. *Takaku Aigai ten.* Tochigi: Tochigi Prefectural Museum, 1975.

Umezawa Seiichi. *Nihon nanga shi.* Tokyo: Nan'yōdō Shoten, 1919.

Yamanouchi Chōzō. *Nihon nanga shi.* Tokyo: Ruri Shobō, 1981.